PORTRAITS OF TIBET

DIANE BARKER

D1449132

BIRD EYE BOOKS

A GRAFFEG IMPRINT

I'm a Tibetan

My skin is the colour of ancient bronze

but

My favourite colour is dark red

I'm a Tibetan

The teachings of my ancestors are engraved on my bones

The sound of horses' hooves flows in my veins

Fragrant barley ale fills up both my eyes

Enchanting gesar flowers bloom on my body

I'm a Tibetan

Tibetan: a name which is matched by reality

Tibetan: standing on the earth, touching the heavens

Remember

Don't ask me for my surname

If you insist on asking for my surname

I'll tell you I am a follower of the Buddha

I am a strong nation blessed by the Tibetan gods

My left shoulder is a hawk

My right shoulder is a yak

My body is a lamp under the statue of the Buddha,

never extinguished.

Anonymous 21st century Tibetan poem

CONTENTS

Tibetan folk song:

Above looms the blue sky, representing

The Wheel of the Sacred Law;

Below lies the pale earth, like an eight-petalled lotus;

Between them rise the majestic mountains,

Manifesting the eight auspicious symbols.

In the meadows grows a profusion of medicinal plants,

The valleys are adorned with green trees and fields,

While turquoise lakes and rivers dot the further reaches.

Pure, crisp air forever refreshes life.

The moon shines brighter amidst the glittering stars.

The earth is full of precious treasures.

On this highland humans and nature coexist harmoniously!

The land where spiritual and human law reigns supreme,

In the land where celestial powers are revered,

Where animals are partners in life's struggle,

Where birds fly without fear,

Where fish swim in freedom,

Where wildlife is protected,

Where men and women cherish inner peace and outer freedom.

FOREWORD

Diane Barker's great love and empathy for the culture of Tibet is clearly revealed in these evocative portraits. The faces of the nomads (and even of the nuns and men-about-town) reflect the harshness of the environment, but their eyes also reveal the beauty and majesty of their surroundings, along with their own good humour and kindness. How well her lens portrays the intimacy of their lifestyle with subtle lighting like a Vermeer interior and reflects her own warm relationship with so many of her subjects, who have become her friends.

For millennia nomads have wandered with their flocks of yak and sheep over the great mountainous plateaus of Tibet, living a life of simplicity and rigour in that harsh climate on the Roof of the World. They lived in tents woven from yak hair and roamed in accordance with the seasons to find pasture for their herds.

It is a way of life that is now threatened by modern inroads, with the desire for education and healthcare causing the breakdown of the nomadic lifestyle, especially in the younger generation. Already the traditional horse riding is being replaced by motobikes and television is there in the yak-hair tent, along with mobile phones!

Their respect and understanding of their environment has protected this fragile ecosystem over thousands of years – its animals, birds, medicinal plants and flowers and soil – but that is now endangered as economic exploitation encroaches.

However, the deep devotion of the people towards Buddhism and the lamas remains so far unshakeable. They have a clear and heartfelt love for their culture and the religion which supports it. It is their identity as Tibetans.

The sensitivity and perception shown in Diane Barker's photography introduces us to an alternative lifestyle not reliant on physical comforts or endless mental distractions. The simplicity of their existence is enhanced by the magnificence of their natural surroundings, which mock our human efforts to dominate.

We trust that this book of exquisite photographs, taken just as modernisation advances ever further into the nomadic highlands, can yet help to awaken in others an appreciation of this unique civilisation which perhaps is foredoomed to disappear, losing forever its precious environmental wisdom and values.

Jetsunma Tenzin Palmo.
Celebrated Tibetan Buddhist teacher and resident
of Dongyu Gatsal Ling Nunnery, India.

A special feature of the nomads is that they are very deeply and intimately connected to the earth so that they know when flowers are going to grow, what stars will pass through the sky, when the seasons are going to change.

Gebchak Wangdrak Rinpoche

INTRODUCTION

I have been photographing Tibetans for about thirty years, deeply inspired by a culture that for centuries has placed the sacred at the heart of life. To be inspired to take photographs I have to feel a real love for my subject, and I certainly fell in love with the landscape of Tibet and its people, who have been the focus of my photographic work since around 1994.

Tibet is well known as the 'land of snows', having the youngest and some of the highest mountains on earth. In a landscape of awesome beauty the average altitude is 14,000 feet and the climate can be savage and extreme. It takes a tough and resilient people to flourish in these conditions, and yet I have found Tibetans to be some of the most open, generous and humorous people I've ever met. It is impossible for me to pinpoint why I was so drawn to these people and their land, but it has something to do with the vast skies, the way the mountains and valleys seemed to sparkle with magic and the great open-heartedness I found there – in others and also in myself.

My interest in photography began during childhood; my mum was always an enthusiastic recorder of family life and there were lots of albums, old tins full of photos and some very old snapshot cameras around the house, bringing with them a natural feeling for recording things for fun. In my teens an Instamatic camera was bought for me and later the affordable 35mm Praktica SLR. I tried out slide films and fell in love with that luminous medium.

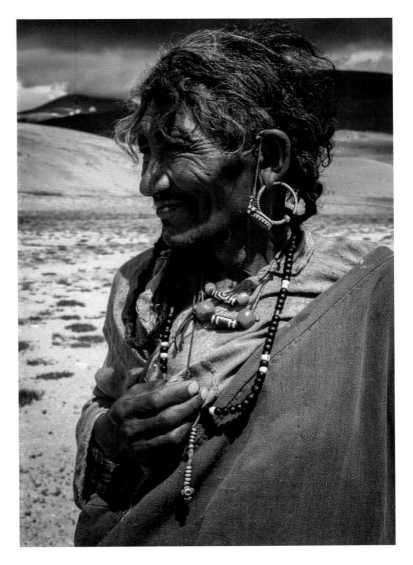

Tibetan nomad, Tso Kar Lake, Ladakh, India, 1999.

Mum also used to bring lots of assorted picture books home from the library van, knowing I loved art and history. Through books on the work of photography masters like Bill Brandt and Henri Cartier-Bresson and Dorothea Lange I began to see photography as more than snapshots and instead as a serious documenting medium and art form.

Later, as a young hippy nomad travelling around America in a VW campervan, I discovered the work of Edward S. Curtis, noted for recording the lives of Native Americans. He became a hero of mine, but his photos also evoked a tremendous sadness, an awareness that the beautiful way of life he had lovingly captured seemed to have disappeared. Even as a young person, there was a longing for this closeness to the earth and a recognition of some beauty that comes from that closeness, together with a longing for freedom, for travel, for a portable life. I subsequently acquired a second-hand Nikon FM, which I was still using and loving years later, along with slide film.

From my early thirties, when some very remarkable women encouraged my artwork, I focused on painting, having been introduced to hand-made watercolours created from traditional pigments and the use of gold leaf. For some years I made small watercolour paintings (often mandalas) about my inner world, and gradually the paintings included people, trees and landscapes that inspired me. Throughout this time photography was always there in the background, used to record things that touched me and as a reference for my paintings.

In my late thirties, travel to India started to become very compelling, answering my need for adventure and freedom and to become closer to a mysterious and colourful land that had inspired my much-travelled grandma. I began documenting my travels there – initially just for myself. For a while I had a Buddhist boyfriend who was teaching English to Tibetan monks in Sikkim, and whilst visiting him for several months I became fascinated by the Tibetan community and started to photograph them. In the early 1990s, on the spur of the moment, I approached a small photo library and to my astonishment they accepted some of my photographs with a lot of friendly encouragement. Photography started to overlap with painting then, and would take over naturally. Painting can be a very solitary and introverted activity, and I think I was ready to emerge and explore, albeit initially hiding quietly behind a camera.

I think I've always had a feeling for earth-based cultures, a heart connection, and in 1999 my love of vast landscapes and high places led me to the Changthang plateau of Ladakh. I was travelling with some locals, and after hours of driving we left the road and cruised across trackless high-altitude desert scattered with quartz and herbs. We eventually crested a rise and saw in the distance a salt lake with a white Tibetan picnic tent pitched beside it and horses nearby.

Out of it emerged these glorious, wild and earthy men with long hair, earrings, home-spun clothes and felt boots – it was like a revelation, a bolt out of nowhere. These were Tibetan (rather than Ladakhi) nomads, probably originally

from Ngari in western Tibet. I realised that here a beautiful, indigenous, earth-based culture was still alive and intact and I was deeply struck by an extraordinary sense of their connection with the environment around them that I had never encountered before.

I spent a week with the local nomad groups, all Tibetan, and was received with warmth, generosity and friendliness as I trailed after them with my camera, inspired and increasingly obsessed. I watched the women milking the dri (female yak) and Pashmina goats, the men driving herds to pasture, the roasting and then grinding of barley to make *tsampa*, the Tibetan staple, and later sat companionably with them in their black yak-hair tents, drinking butter tea.
This experience was down to earth and yet profound, awakening some ancient memory inside me, and was rather like falling in love. In no time I was compelled by a clear determination to travel to Tibet to explore the life of the Tibetan nomads, one of the last great surviving communities in the world. In just over a year, the dream became reality.

Between 2000 and 2019 I travelled to Tibet nearly annually and was privileged to be able to stay with nomad families in Kham and Amdo in old eastern Tibet (now Sichuan, Gansu and Qinghai Provinces of western China), enamoured of their independent spirit, their hospitality and sense of fun. I feel that all the nomad people I have met have an unusual, primordial sort of power and dignity whilst also being refreshingly simple and uncomplicated – they have a raw energy, a tremendous vitality that can rarely be seen elsewhere.

I want to portray the people I photograph with as much compassion and dignity as possible. When I stay with a family there is a necessary trust and I try to be a peaceful presence, respectful and unobtrusive, so that the images reflect a certain relaxed intimacy. I look at a Tibetan nomad mother with her child, see the way the light falls on them both and marvel at the beauty, the colour, the tenderness. They have allowed me into their lives, which is an enormous privilege. When on the move, travelling around with Tibetan friends, I also come across scenes spontaneously – dusty pilgrims returning from circumambulating a mountain, swaggering guys on the street shopping or hanging out together, devoted local families at monastery festivals, Drokpa friends chatting in a cafe. I still don't speak Tibetan, even after all these years, but that allows me to concentrate on being still and just looking while my Tibetan friends do all the talking and my hosts relax. Photography is a meditation for me.

Diane Barker.

FIRST JOURNEYS

I had first encountered people from Tibet in 1977, when out of curiosity I found myself at the Black Crown ceremony conducted by the 16th Karmapa, Rangjung Rigpe Dorje, spiritual leader of the Karma Kagyu lineage of Tibetan Buddhism, in a small farmhouse in the Welsh borders. As I watched the powerful ritual being conducted by a great master and his small entourage, perhaps a seed was sown – or something re-awakened.

Just when it seemed it may prove impossible due to lack of funds and connections, a first visit to Tibet materialised in the year 2000 when I connected with Chodrak, who invited me to accompany him on a visit to his nomad family in Amdo in late August that year. With barely a month to prepare, I scrambled to gather the supplies and funding I would need: sleeping bags, suitable clothes and a good jacket, loaned from my American friend, Hilary, an experienced camper and trekker; she would accompany us on the trip, linking up with Chodrak and I at Chengdu airport. Fortunately, my old Nikon 35mm film cameras were very light and I was used to carrying two film cameras around in a backpack from my time spent in India.

I was excited. Eastern Tibet in earlier times was greatly feared by travellers for the 'wildness' of its fiercely independent people, who were considered to be formidable warriors and bandits, owing allegiance to no one but their own tribe. The names of the legendary Khampa and Golok tribes would evoke fear among merchants, pilgrims and explorers travelling through the area from China to Lhasa. Alexandra David-Néel, the first European woman to visit Lhasa, referred to the area as 'the land of the gentleman brigands', noting also their chivalry and devotion to Buddhism. I was wondering if I'd still find the wild west – in eastern Tibet.

Having passed a few days in Chengdu, with its curious mix of Western fast-food outlets and neon lights alongside tea gardens, very early one morning we headed north in a four-wheel drive to the grasslands of Amdo. The flat farmlands around the city gave way rapidly to mountains scored by deep gorges, the then brand-new freeway suddenly changing to narrower roads, ever decreasing in quality, hugging the sides of river canyons.

Our life is shaped by our mind; we become what we think.

With a clear mind, joy will follow our thoughts and actions like a shadow.

The Dhammapada

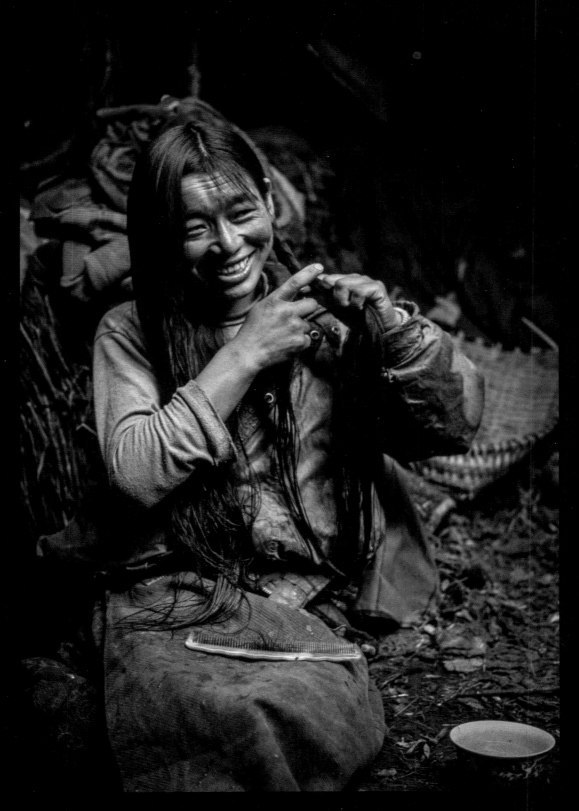

Yeshe combing her hair in the family black tent. South Amdo grasslands, 2000.

Eventually, late in the afternoon, after climbing through forested alpine terrain, we crossed a high pass, entered the grasslands of southern Amdo and reached Chodrak's home village, where his mother and Chinese stepfather now lived. Here we were to meet his brother Choephel, who would take us on to his tent, two days' ride into the grasslands. Though an inexperienced horse rider, once on I soon took to our journey through the rain, the beauty and silence of the landscape, the sense of freedom and spaciousness and the friendliness of our escorts.

The first night we stopped and made camp in a lush alpine meadow, reaching Choephel's tent high on the furthermost ridge the following day and being introduced to Choephel's wife Yeshi and two-year-old daughter Dolma Kalsang in the smoky gloom inside. Yeshi's schedule seemed to be a relentless one of rounding up and milking fifty yak twice a day, turning the milk into butter, curd or cheese, collecting and drying yak dung and brush wood for the fire, collecting water and preparing meals.

Her radiance and unflagging cheerfulness, warmth and humour were both humbling and remarkable. For me it is the women who seem to hold nomad life together and undertake most of the work, and with that have a sense that they are the unsung heroines who have been particularly important in keeping faith, hope and the Tibetan culture alive in recent decades. I was privileged to spend time with them in the black yak-hair tents, the warm heart of nomad life – the place for eating, sleeping, making butter, cheese and curd, socialising, saying prayers, making and having babies, dying.

Dolma Kalsang, whom we watched as a small form of help, seemed to be made of cast iron, impervious to cold, dirt and boiling kettles. Easy-going people, Choephel and Yeshi had an extraordinary quality of inner stillness, simplicity and contentment that created a sense of peace and space around them. There was a quiet freedom in sitting companionably with them, drinking tea and saying nothing at all – the mind stilled.

Using film in the dark interiors of the black tents (and in the Tibetan houses I visited later on), I was always looking for pools of light from smoke holes in the tent roofs, or from windows, the grain or noise of the images giving atmospheric and painterly results and, although not always conscious, showing traces of some of the painters I have admired.

One morning we woke up to snow, and the ridges around us blended into a lowering grey sky, giving me the sense of an endless nothingness. Odd patches on the ground where the grass was a little longer or a tent had recently been pitched, disturbing the earth, gave a speckled look to the landscape – I had the uncanny feeling of standing on the back of a huge snow leopard. Choephel and Yeshi had, as usual, been up for hours, rounding up and milking the yak, and Dolma Kalsang was tottering around barefoot in the snow, oblivious to the cold.

During my evenings spent with the family their welcome overcame the lack of much common language, and Choephel especially had a real gift for mimicry, meaning we had little trouble at all communicating. Young male friends of Choephel's would occasionally come by and take a look at the strange visitors, or to try out the guitar that Chodrak had

bought for him on the way up from Chengdu. Later we would make our way back to our tiny tents higher up the ridge, carefully negotiating the spider's web of guy ropes. The silence of the nights was fathomless, pierced occasionally by a round of barking dogs or the coughs and groans of the yak.

When the time came to leave, we sang our way back across the beautiful grasslands, punctuated by rests for our very sore backsides, and were chivalrously delivered to a very early morning bus by Choephel and his friend. They made sure we were the first to board, and awkwardly and inexplicably we were the only people of the large crowd gathered who were allowed on. I searched for their handsome, friendly faces in the seething crowd but could not see them. The rusting bus lumbered away without us being able to say a last goodbye.

Back in Chengdu, Hilary and I took our clothes, encrusted with two weeks of grassland mud and yak dung, to the laundry in our hotel and were astonished when they were returned to us as good as new. Hilary then moved on to further travels in India and I set out on a solo two-day journey by bus to Lhagang, a small town in Kham surrounded by nomad grasslands. As I'm no linguist, I fortunately met a young Swiss academic in Dartsedo and we travelled together to Lhagang, staying in the monastery guest house for two brief days. We roamed the town and went back and forth to visit three friendly Drokpa women – a mother and two daughters – at their camp in the nearby grasslands. My new Swiss friend then met up with her husband, who had cycled all the way from Chengdu, and I returned there, relieved that I'd managed a brief excursion on my own.

After a few days I joined Chodrak and three of his friends on a three-week road trip to Lhasa in his friend Doko's four-wheel drive, travelling down to Lijiang in Yunnan Province and then up to Chamdo via Gyeltang and Dechen through stunning alpine and forested scenery. At one point Chodrak insisted that we stop to talk to three young girls we saw, covered in dust, walking along the road just south of Chamdo. They were nomad pilgrims, travelling alone and carrying their needs (tent, food and bedding) on their backs. They were returning home on foot from circumambulating the sacred mountain Mount Kawa Karpo, over 200 miles to the south. The range is an important focal point for pilgrimage, revered as one of the twenty-five important meditation sites associated with Padmasambhava in Kham and Amdo, with the inner *kora* path, which takes eleven days to complete, considered very dangerous due to the challenging terrain.

At first the three pilgrims were very shy and one, typically for young Tibetan women at the time, covered her face whenever I raised my camera. Then they relaxed and told us of their journey. I met them again, a day later, making *kora* along with many other devotees, around Kalden Jampaling Monastery in Chamdo. My photos of them and of Yeshe in the setting of the family's black tent mean the most to me from my very first travels in eastern Tibet.

Pilgrimage to sacred places has long been an important part of the Tibetan Buddhist way of life, as a way of affirming one's faith, as a way of accumulating merit (gaining beneficial energies or positive fortune through good deeds), as a purification and as a meditative practice.

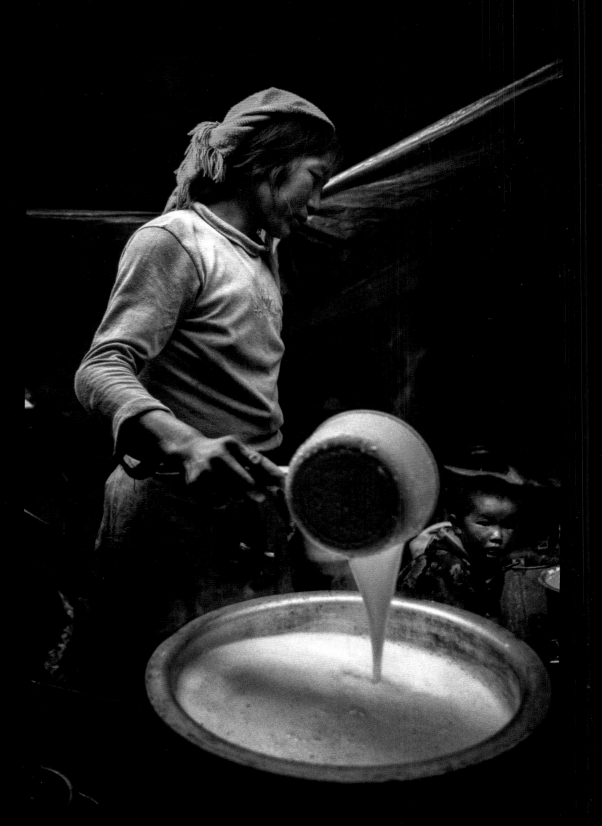

Nomad life – Yeshe heating milk for butter and yoghurt making. South Amdo grasslands, 2000.

In Tibetan, the word for pilgrim is *gnas skor ba*, which loosely translated means 'one who circles a sacred place'. *Ne*, or sacred places, can be natural sites of power like mountains, such as Kawa Karpo and Amnye Machen in Amdo, caves, springs, rocks and sky burial sites, man-made sites such as monasteries, stupas, hermitages and also holy persons and even *beyul*, or hidden lands. The merit or purification is greater if one goes on foot to and around the sacred site, and even more powerful if the pilgrim performs prostrations. It is not uncommon to come across pilgrims making prostrations all the way from north-eastern Amdo to the sacred Jokhang Temple in Lhasa and even on to another sacred site, Mount Kailash in western Tibet.

Traditional Tibetan culture knows the outer world as a reflection of the inner world; its values and practices connect the two so that they can nourish each other. Nature is alive with deities and spiritual energies and sacred sites throughout Tibet are revered as places where these worlds meet, where the separation between inner and outer, spiritual and material, is especially thin. Hanging prayer flags, burning incense (usually juniper branches) and saying prayers are just some of the traditional ways of honouring sacred sites.

But for Tibetans, nature is deeply respected regardless of these 'special' places. A harmony still exists and is kept alive by those, like the nomads, whose lives intertwine with the land. Today environmental scientists acknowledge that the approach of such indigenous peoples can make significant contributions to protecting endangered species and conserving biodiversity. What's needed now is not just a return to respecting the land, but to develop a respect for those who have done so for millennia and the knowledge, skills and wisdom they hold.

Yesterday, as the two of us were talking, one thing I said was, 'Wherever there is real living of life, there is beauty.' If you want to experience the beauty of living life, your heart must be attentive to it.

Trachang Palsang, nomad from Ma Chu area

One should honour women,

Women are heaven, women are truth,

Women are the supreme fire of transformation.

Women are Buddha, women are religious community.

Women are the perfection of wisdom.

Candamaharosana Tantra

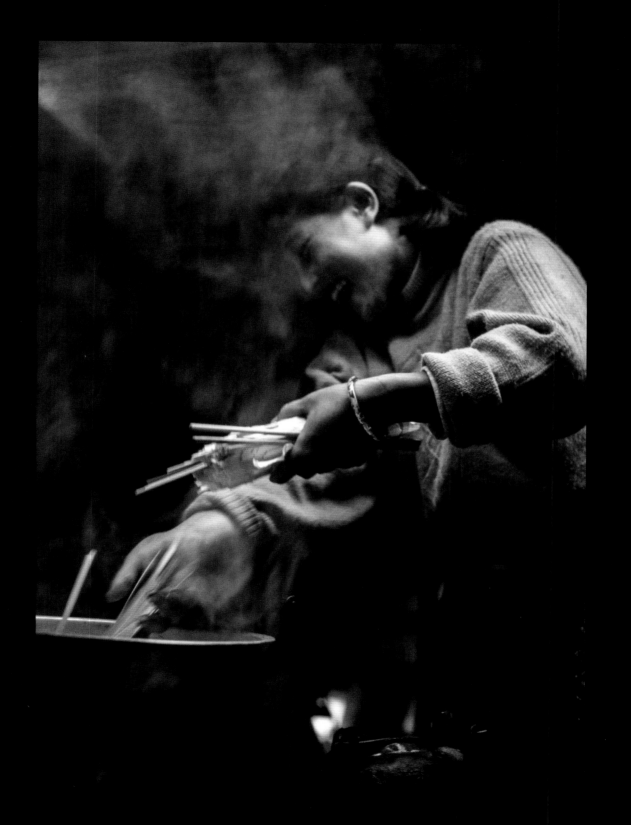

Yeshe's friend cooking noodles in her black tent. South Amdo grasslands, 2000.

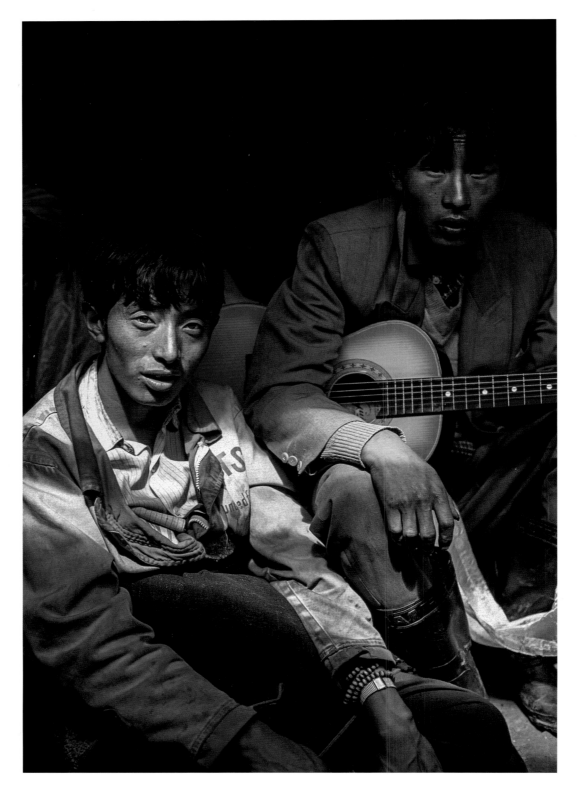

Yeshe's husband Chophel with the guitar his brother brought him from Chengdu. South Amdo grasslands, 2000.

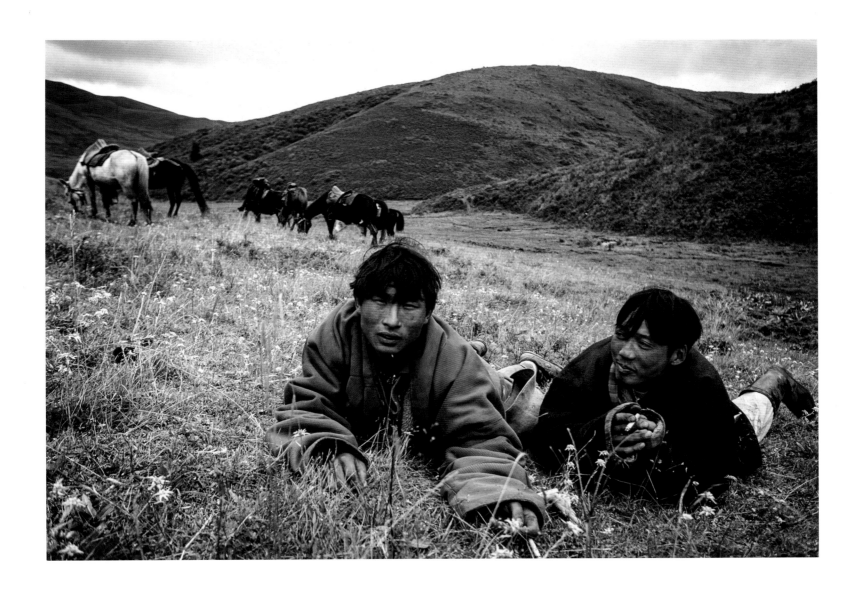

Chophel and a friend have a cigarette break. South Amdo grasslands, 2000.

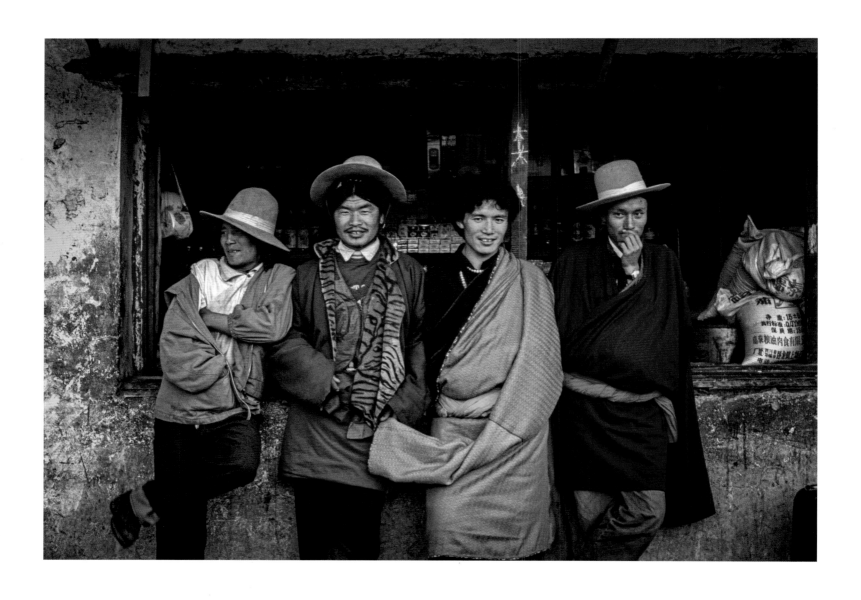

Bashful young cowboys. Lhagang, Kham, 2000.

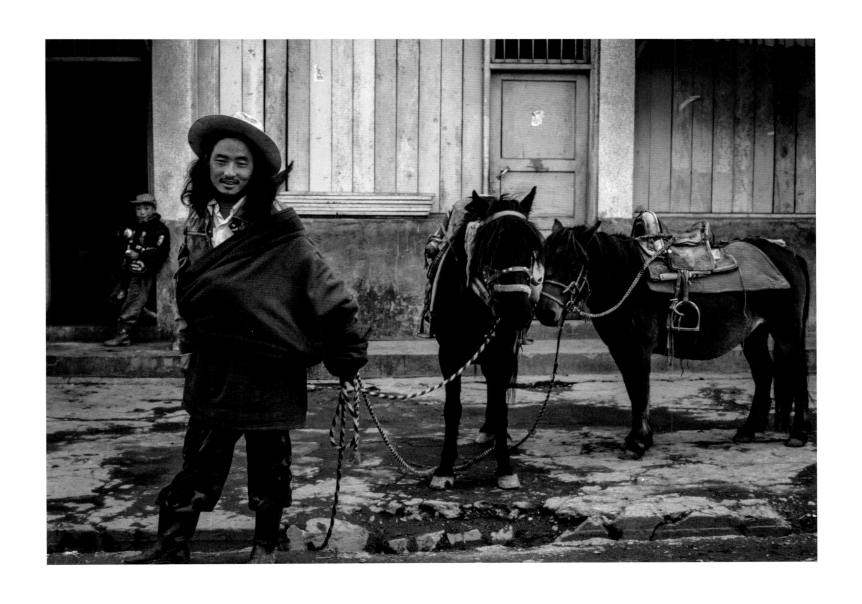

A nomad comes to town, keeping his shopping in his *chuba*. Lhagang, Kham, 2000.

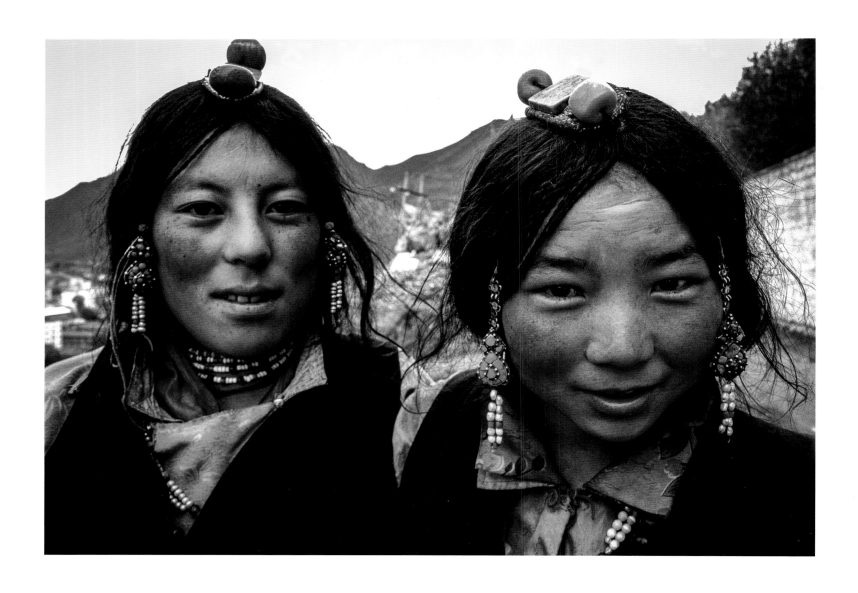

Sisters circumambulating Kalden Jampaling Monastery. Chamdo, Kham, 2000.

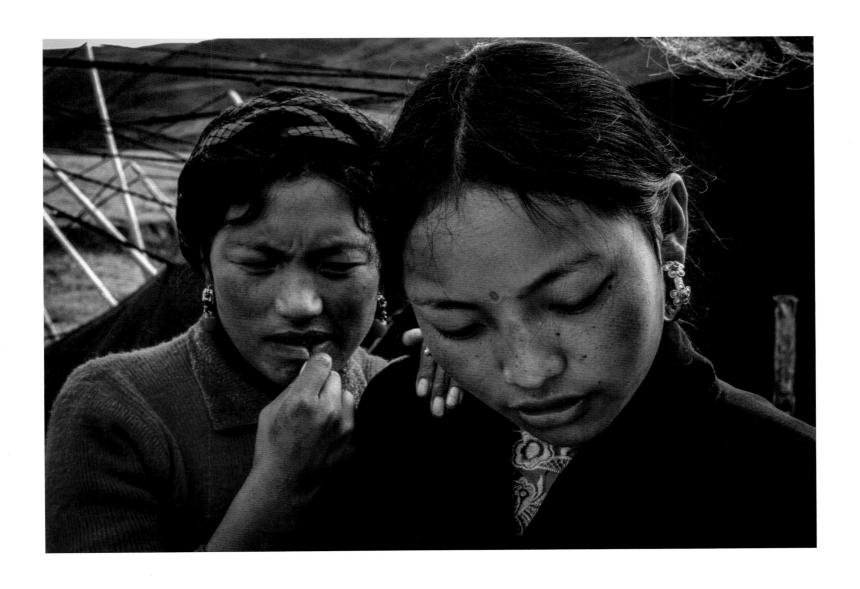

Nomad sisters. Near Lhagang, Kham, 2000.

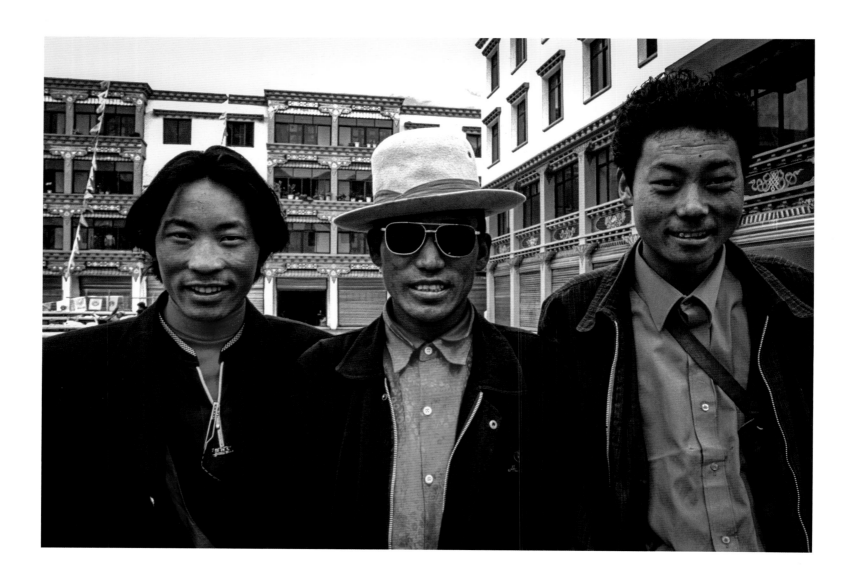

Locals, Chamdo, Kham, 2000.

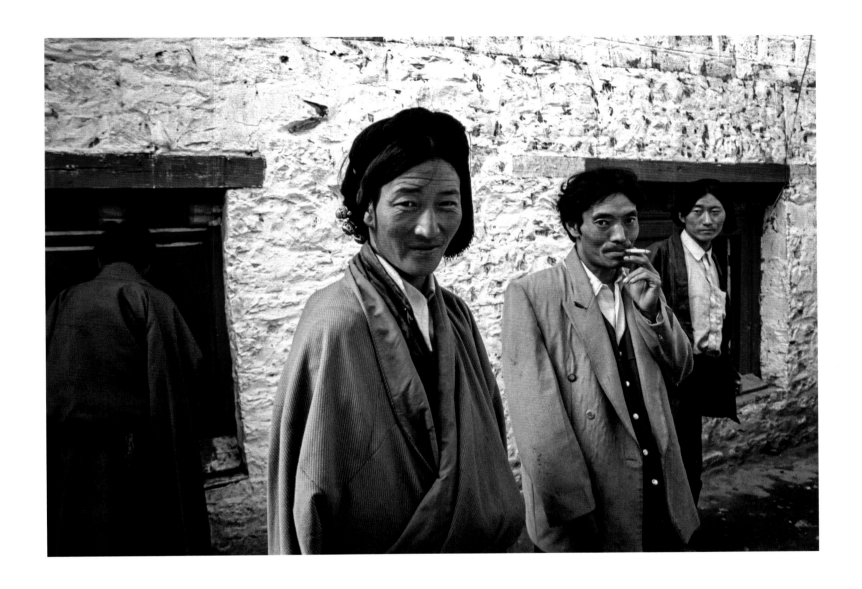

Local men, Chamdo, Kham, 2000.

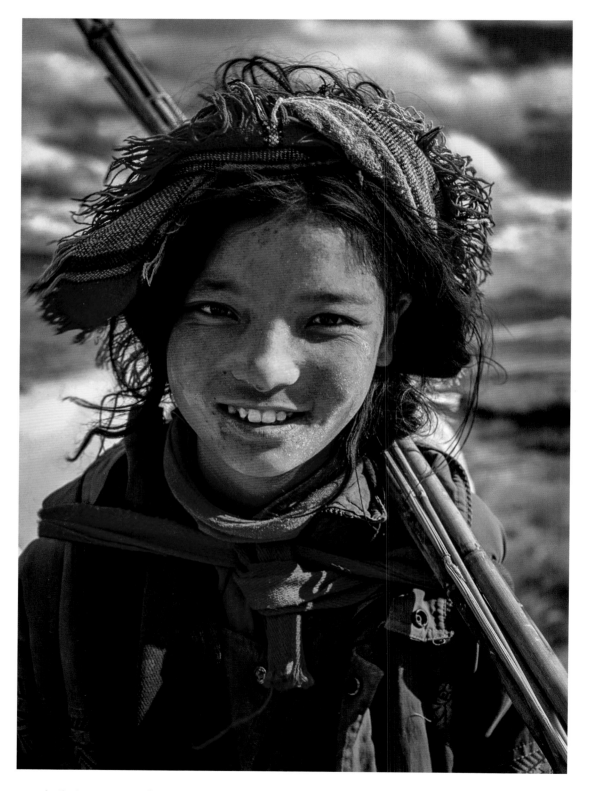

Young nomad pilgrim returning from circumambulating Mount Kawa Karpo. Yu Chu Valley, near Chamdo, Kham, 2000.

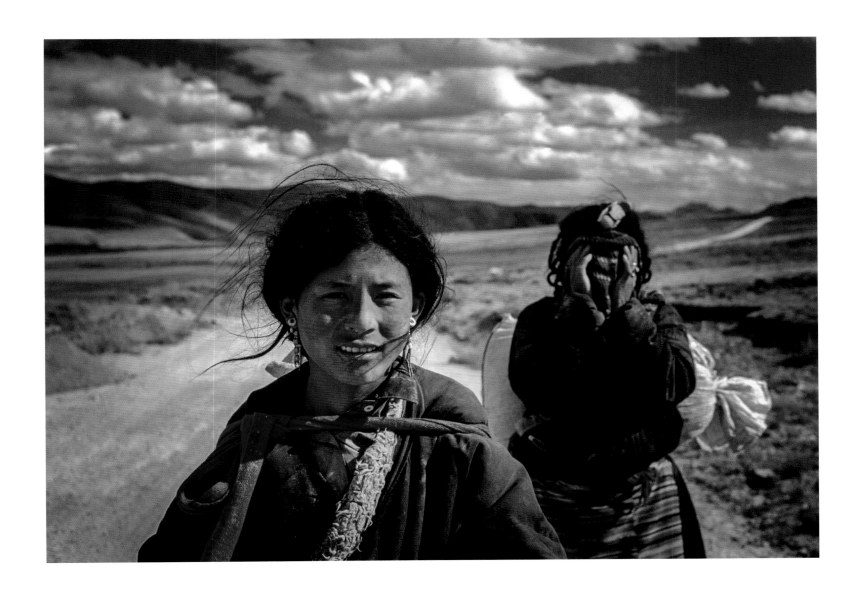

Young nomad pilgrims returning from Mount Kawa Karpo. These three young women were travelling alone and carrying their tent and food on their backs. Yu Chu Valley, near Chamdo, Kham, 2000.

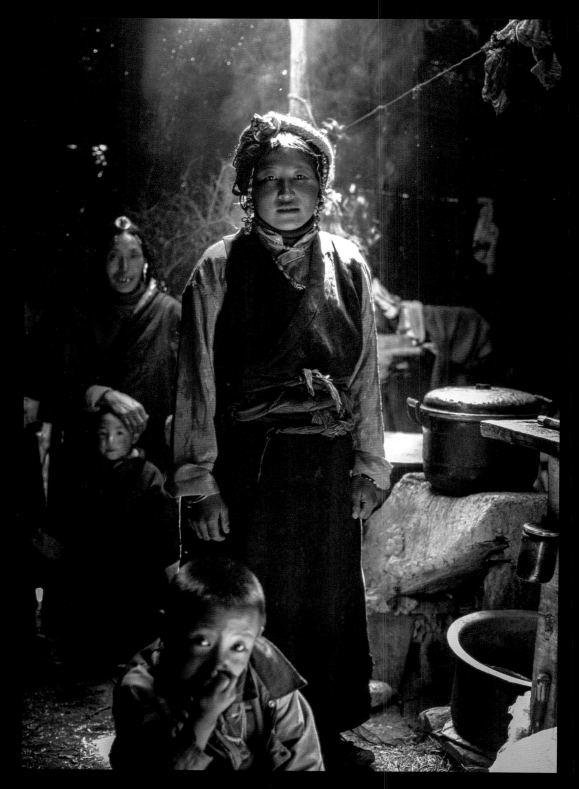

Sersong's daughter in the family black tent. Taerlung Dilgo area, Kham, 2001.

TRAVELS WITH OGA

In the summer of 2001 I travelled back, full of longing for wild earthiness, beauty and the vastness of eastern Tibet. I felt I had barely begun to explore life there. A friend connected me with Oga, a Tibetan woman who had lived in Germany with a Tibetan Rinpoche uncle and his German wife for some years, and she agreed to me joining her on a trip to her home area in Kham.

Oga and I met in a hotel in Chengdu and the next day embarked on the long four-day bus journey to Derge. On our arrival, Oga organised a shopping expedition to buy gifts of food supplies to give to the people we would stay with as well as to buy local clothes which would demonstrate the admiration we held for their culture. Next, we hired a jeep and set out for her home valley of Taerlung Dilgo, five hours or more from Derge, for a time following the steep-sided gorge of the Dri Chu.

We spent a month travelling around Oga's area on horseback nearly every day, meeting her friends and relations, talking to local people and attending horse festivals and celebrations to welcome the visit of Dzongsar Khyentse Rinpoche. Dr Lodre Phuntsok, the celebrated manager of Dzongsar Monastery, was an inspiration, having brought back the traditional pottery, wood and metal crafts of the region, along with Thangka painting, and as a noted Tibetan herbal doctor had created a new traditional Tibetan herbal medicine hub and training centre.

Dr Lodre's origins were extremely humble, but his heart and resourcefulness were leading locals to begin to call him Lodre Rinpoche, *rinpoche* being an honorific title in the Tibetan language meaning 'precious one', convinced that he was an unrecognised *tulku*, or accomplished reincarnate Tibetan Buddhist teacher. He had a beautiful wife and eleven children, most of whom seemed to be doctors, or aspired to become one. It transpired that in this area many locals were semi-nomads, having handsome winter quarters in the village and taking their animals up to the high pastures in the summer. We were invited to one such summer camp by Sersong, hiring horses and climbing high above and beyond the village to reach his family's tent.

Immaculate and very well organised in the traditional way, it had the most magnificent and sculptural clay stove in the centre, blackened from use, over which an assortment of ladles, bags and pieces of meat hung from a length of string. The tent entrance was made draught-proof by a beautifully constructed but simple screen of brushwood. Nearby were the tents of other families, relatives of Oga, and when we visited and the local news and views were discussed I sat quietly with my camera until everyone would, hopefully, forget I was there and I could take pictures under the light falling through the tent's smoke hole.

My worry for the future of these remarkable people is what the effects of education will bring. On the one hand, remote rural areas of Tibet have until recently been hampered by a lack of education, finding it particularly hard to advance in more 'modern' society and so climb out of poverty. On the other hand, something beautiful had been left alone, a way of living that was less concerned with materialism and rationalism than it was with stillness and visionary experience. Thankfully, for now, many still enjoy a sensitive relationship with their environment, a respect which leads them to be, crucially for this time, instinctive ecologists.

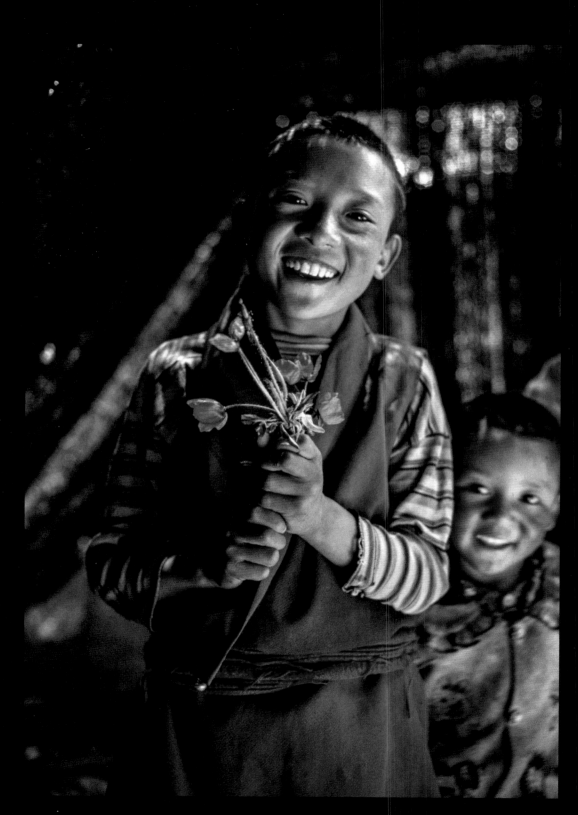

32 Oga's young cousin brings her some pulsatilla flowers, often used in Tibetan medicine. Taerlung Dilgo area, Kham, 2001.

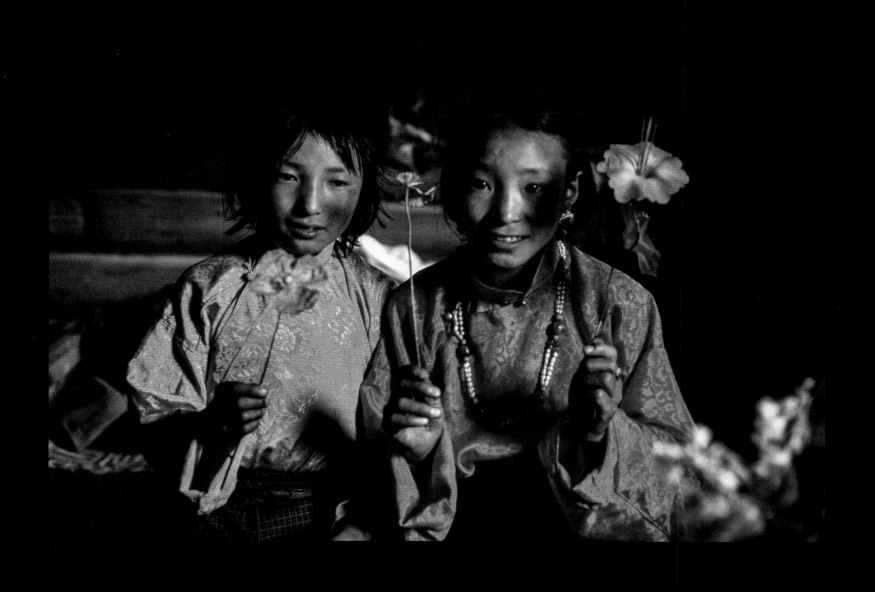

Girls with flowers. Phuma Shen, Kham, 2001.

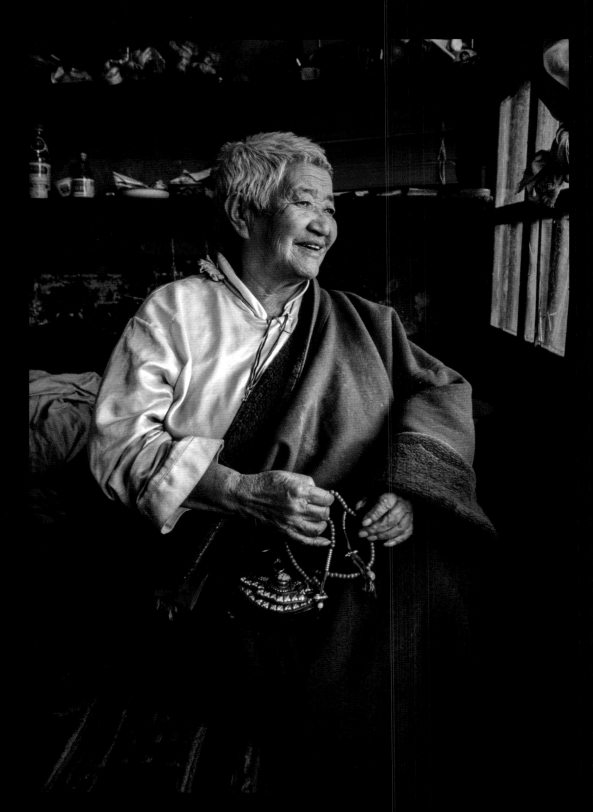

Dr Lodre Phuntsok's mother in her room. Dzongsar Monastery, Meshu area, Kham, 2001.

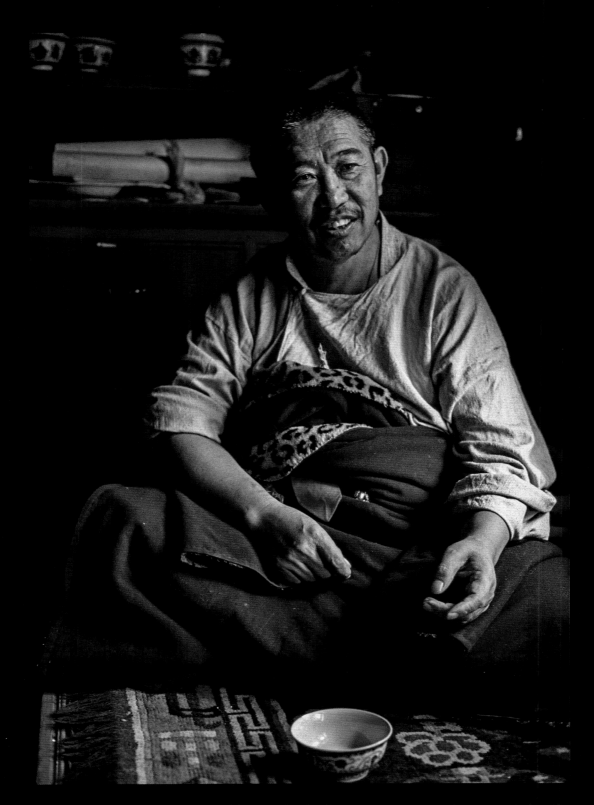

Dr Lodre Phuntsok, celebrated Tibetan herbal doctor, in his family quarters. Dzongsar Monastery, Meshu, Kham, 2001.

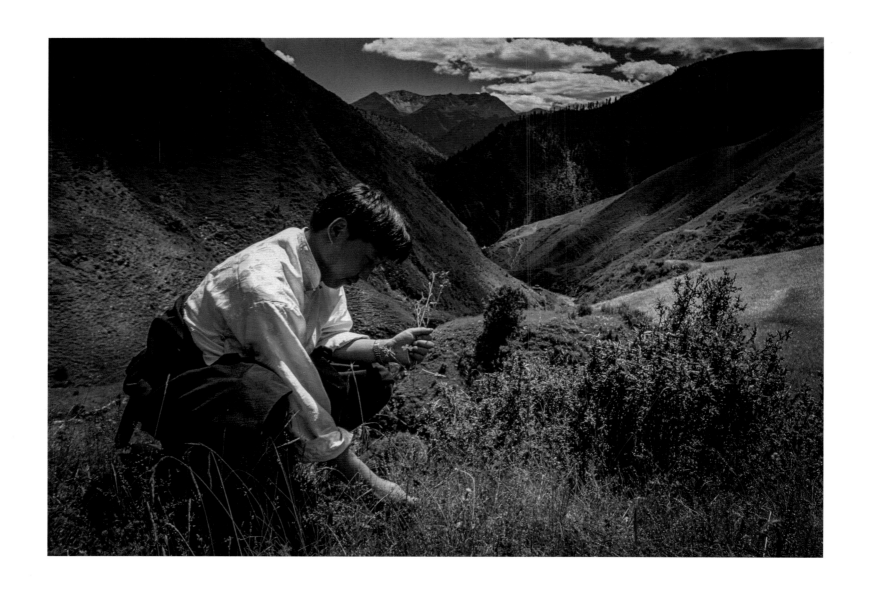

Dr Chime Dorjee, son of Dr Lodre Phuntsok, collecting some of the medicinal plants used to make a remedy for *kasha*, or foot-and-mouth disease. Dzongsar, Meshu (Meshu meaning 'Valley of Herbs'), Kham, 2001.

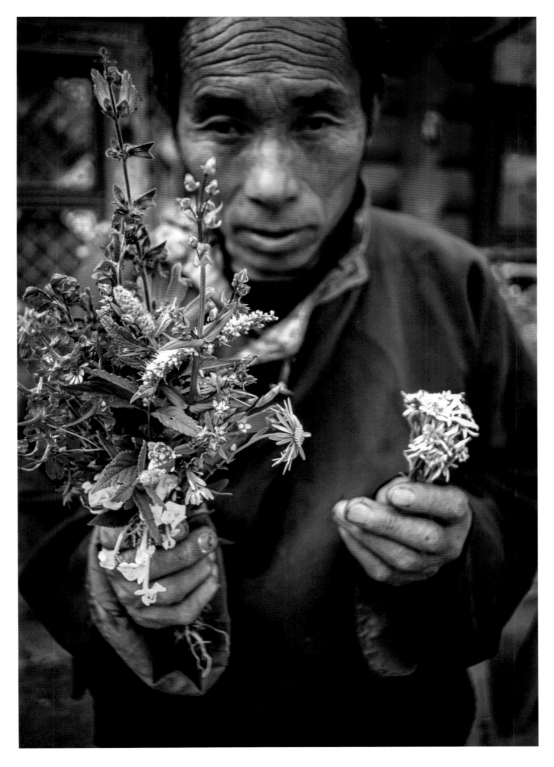

A local man holds the plants collected by Dr Dorjee in his right hand. In his left is edelweiss, used in Tibetan medicine and as tinder for fire lighting. Dzongsar, Kham, 2001.

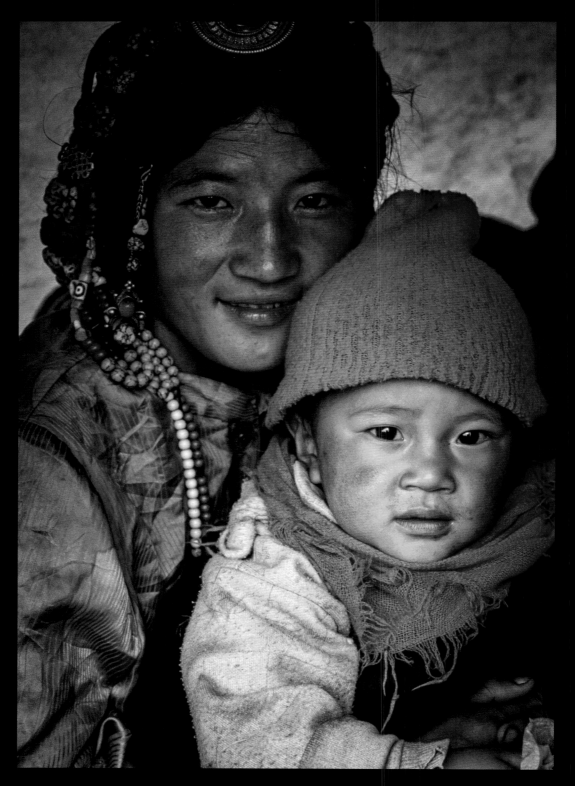

Tashi Yangbo, one of Oga's cousins, with her daughter. Taerlung Dilgo area, Kham, 2001.

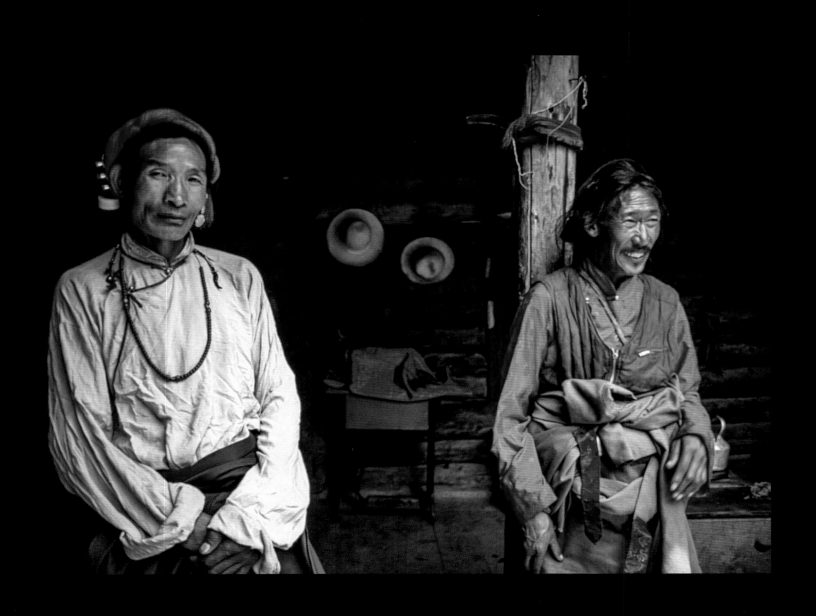

Dawa Sangpo with Oga's uncle, Yeshe Gyatso. Dzongsar, Meshu area, Kham, 2001.

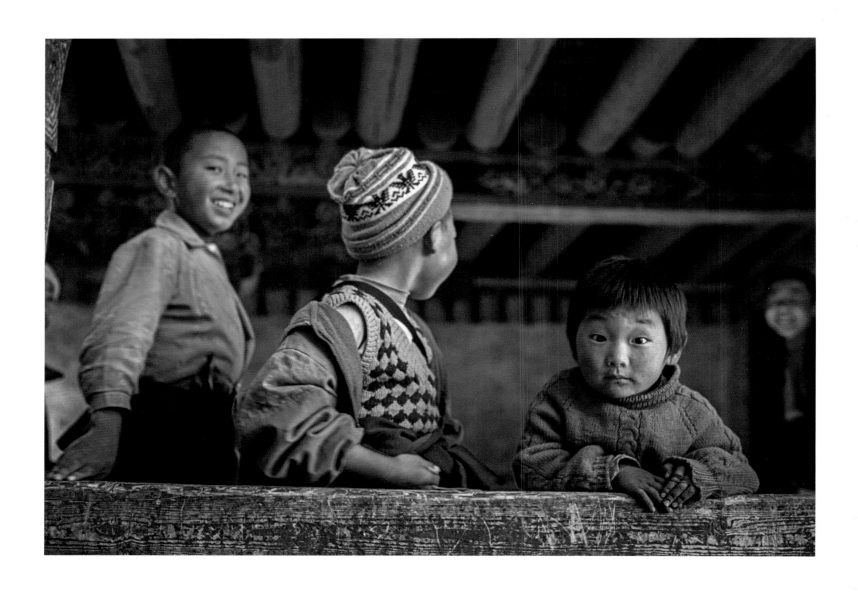

Children at Dzongsar Monastery, Kham, 2001.

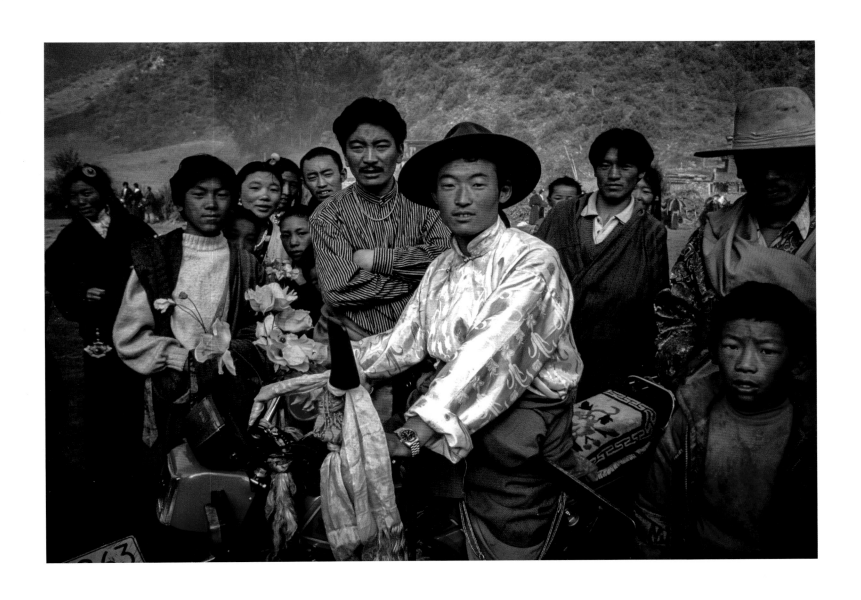

The bike I rode pillion on to a picnic given in honour of Dzongsar Khyentse's visit to Dzongsar Monastery.
Doh-pu Valley, Kham, 2001.

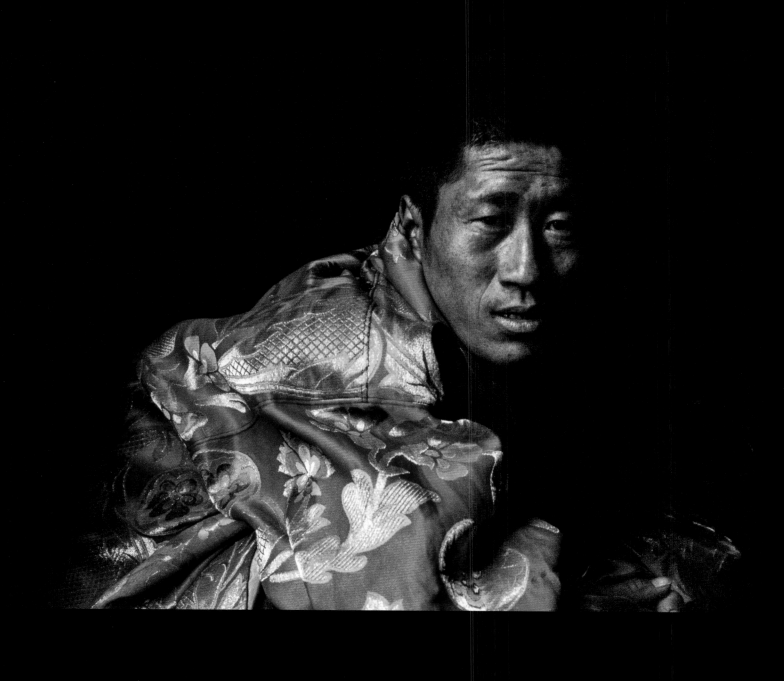

Young Bonpo monk wearing brocade robes for his monastery's Lama Dances. Khyanglung Gonpa, Taerlung Dilgo, Kham, 2001.

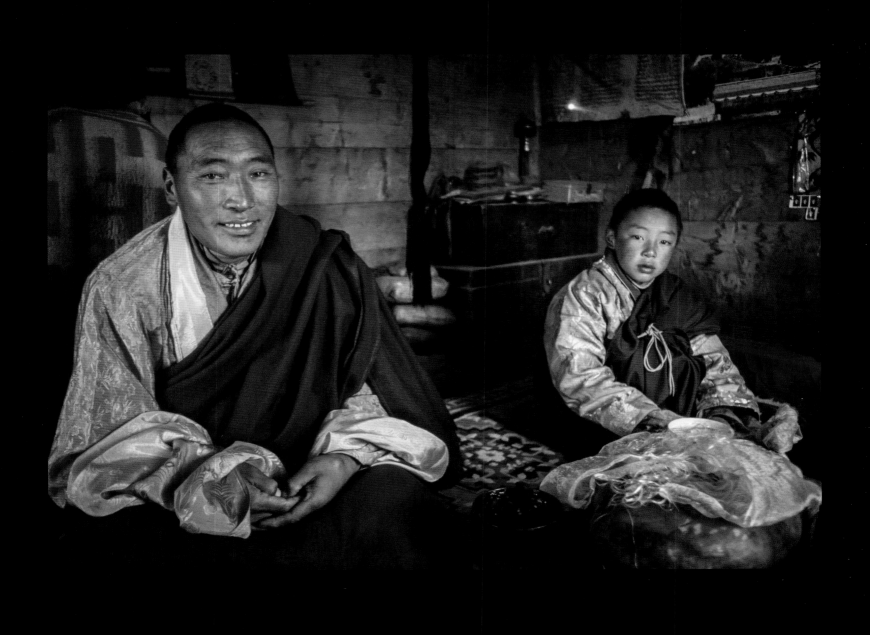

The young reincarnation of the Bonpo *tulku* Tsewang Rigzin (known locally as Dilgo *tulku*) of Khyanglung Gonpa, Taerlung Dilgo, seen here with his tutor in Ngawang Nga-pa, Kham, 2001.

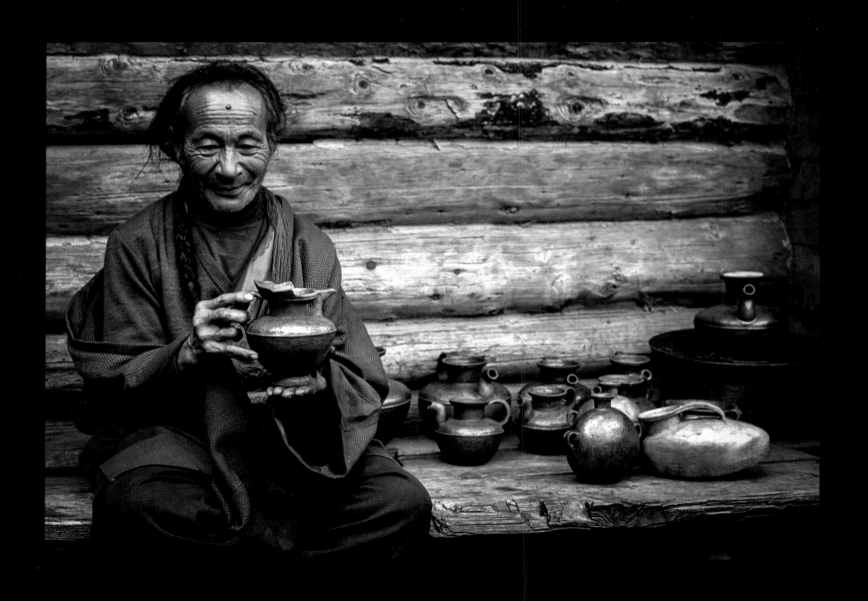

Considered very healthy to drink from, the making of black pottery vessels was revived by this master. He is holding a jug
which will be filled with *arak* (spirits) or *chang* (beer) during a marriage ceremony and decorated with butter at the top.
The holder will sing a special song to wish the couple luck and happiness. Phuma Shen, Kham, 2001.

A Khampa marriage song:

The Good steed is like a swift bird,

The golden saddle is like its feathers,

When the bird and its feathers are together

Then the great Highlands are easily crossed.

The ornamental musket is like thunder in the sky,

The black powder is like lightning in the sky,

When both lightning and thunder meet

Then the high hills are illuminated.

The young tiger man is like the sun,

The young girl is like the full moon,

When the sun and the moon meet

There is happiness in the village.

THE ONLY CONSTANT
IS CHANGE

In 2014, when I returned to eastern Tibet after a gap of five years, I was shocked by the scale and speed of the changes I witnessed.

There were so many improved roads and tunnels through the mountains (I counted fourteen tunnels between Chengdu and Kangding) that increased the speed of getting around and the pace of change – journeys that a few years earlier had taken two days now took less than one.

I had already seen by 2005 how eastern Tibet was moving swiftly from a horse culture to one of motorbikes (and in later years even small vans and cars) at such a pace that the modern Tibetan word for motorbike is *trulta*, or 'motorhorse'. I was told that a motorbike is cheaper than a good horse but heard many stories of nasty accidents as people learned to adjust to the new way of getting around.

I was aware of electric lines, dams, more and more solar panels in certain areas and mobile phone masts. The mobile phone soon became ubiquitous, even at nomad camps – although there was very often no signal in the remoter summer camps. The Tibetan word for 'apple' (*kushu*) and for 'monk' (*kusho*) sound similar, and so many monks now hold iPhones that some Tibetans, tongue in cheek, refer to Apple iPhones as '*Kushu* phones'.

There were also changes in clothing, particularly apparent in lay men. The long hair of Khampa men, usually wrapped around the head in plaits, had given way to short cuts (even perms for a while for some young men), and in summer the *chuba* was replaced by North Face jackets and jeans. Women were slower to change but school and college-going girls were moving to urban wear of jeans or leggings and sweatshirts and less complicated hairstyles. Traditional clothes and jewellery were seen less and less every day, but were brought out for religious and horse festivals, picnics and weddings, and heavy *chubas* were still worn in the winter for warmth, while guns and knives vanished.

Gifted youngsters in rural areas who had managed a mainstream education were often moving to the cities, looking for civil service or teaching jobs, or other opportunities.

In many areas the beautiful black woven yak-wool tents of the Drokpa that looked so much in harmony with the landscape were being superseded by white canvas ones – lighter to move around, but that somehow did not have the same presence in the landscape.

Most significantly, there were fewer and fewer nomad camps themselves visible from the highway and it became increasingly apparent how many Drokpa had taken the option to move to resettlement villages of austere concrete bungalows (and later prefabricated metal houses) on the edge of towns or near to roads. In 2014, after travelling for two days west from Kangding without seeing a single black tent, my heart burst open when I did spot a small *rukor* (encampment) of tents between Manigengo and Dzogchen. However, I also experienced a deep sadness, beginning to feel that I was witnessing the dying of a beautiful earth-based culture. Now equiped with two heavy Nikon digital cameras, I wanted to capture the beauty and simplicity of nomad life and celebrate its value. Nomads have lived lightly and in a self-sustaining way on the land for millennia – they strike me as the ideal stewards of the high-altitude grasslands.

As a river rushes to the sea,

As the sun and moon glide across the mountains of the west,

As days and nights, hours and moments flee,

Life flows away, inexorably.

Padmasambhava (8th century)

THE DONG TSANG CLAN

The Nangchen area in Kham is affectionately known by local Buddhists as Gomde, the Land of Meditators, as even the simplest nomads were known for practicing meditation during daily tasks. It is a beautiful landscape of dramatic limestone and sandstone cliffs, often with caves, and rolling grasslands. Until recently, approximately two-thirds of the population were nomads, but in twenty years or so 80% of that pastoralist population have been encouraged, or have chosen, to settle close to the towns.

During my first trip there, back in late September 2009, I had the good fortune to meet Wangdrak Rinpoche, one of several Buddhist teachers, or lamas, who guide and care for Gebchak Nunnery, the mother nunnery of a wide network of hermitages in eastern Tibet. Gebchak Nunnery has a strong tradition of experiential meditation practice, and most of the remarkable women living there were originally from nomad families.

I met Rinpoche again in Nangchen in 2014, staying at his sister's house with my dharma sister Chozom (who is also Rinpoche's Tibetan to English translator), and later at his brother's nomad camp. Wangdrak Rinpoche's family believe they are descended from Ling Gesar, Tibet's great warrior hero, and Rinpoche has named his hermitage, Dong Tsang Ritro, after one of Gesar's descending clans. He has become a wonderful friend and introduced me to several members of his family – I am honoured that they now consider me a family member. His brother and wife live at one of the family nomad camps, about five hours from the county town where his sister has a house.

Wangdrak Rinpoche is a treasure trove of local nomad lore. For example, he explained that the layout of a nomad black tent, both exterior and interior and its placement in the landscape, is based on a tradition of Tibetan geomancy dating back thousands of years. It is a tradition that respects the land and its unseen powers and views it as sacred – to be treated with respect. He also related how the nearby mountains are venerated as deities and told stories of his family's encounters with nature spirits, which sometimes manifest as a ball of light.

Rabten, Rinpoche's brother, and Demtso, his wife, welcomed Chozom and I to their black tent and made us very comfortable – we were even tucked in at night, and as we prepared to sleep in a kind of cosy and companionable heap on one side of the tent with the youngest children, I felt very cared for and involved. In the morning there was quite an awakening as the adults were up before dawn to start the daily milking. The family has around 200 dri and yak in total, and so they need plenty of help, but as the older children now live in town in order to go to school there is a shortage of hands to help with all the daily tasks, a situation that affects many nomad families. Rabten and his brother-in-law, Digpo, take on jobs traditionally considered women's work, like milking and collecting yak dung as fuel. In the school holidays the children return from their schooling in the county town and help out. I was aware that one of the boys really disliked school and was known for being naughty, but back at the camp he was in his element and I could see that he was probably the future of this nomad camp.

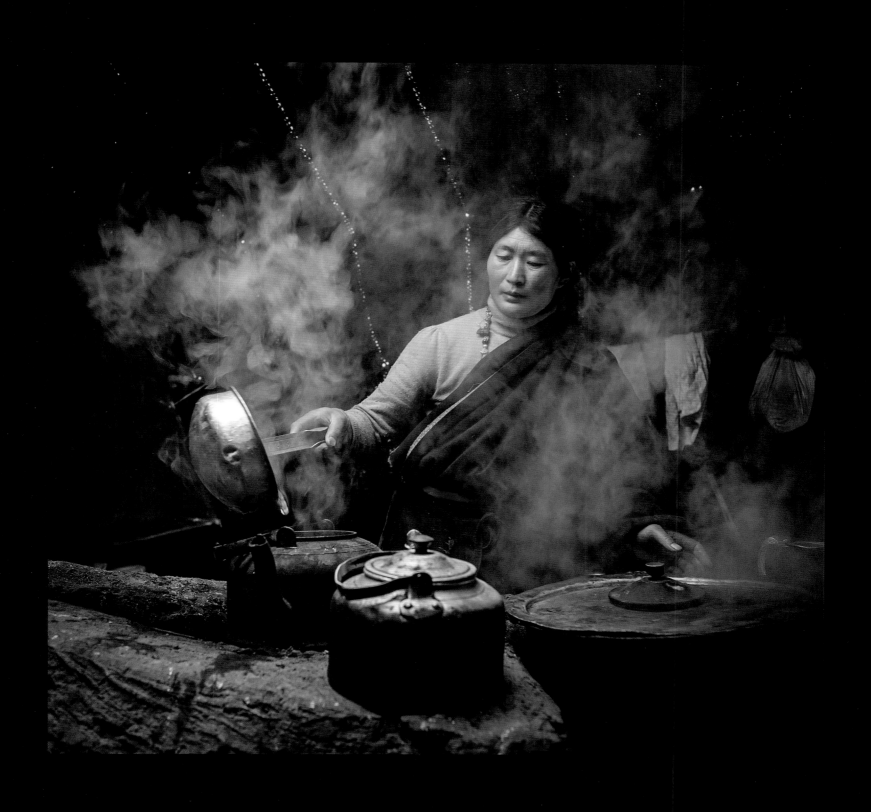

At a nomad camp of the Dong Tsang clan, Demtso makes tea in the family's black yak-hair tent.
Lalung Valley, Nangchen, Kham, 2014.

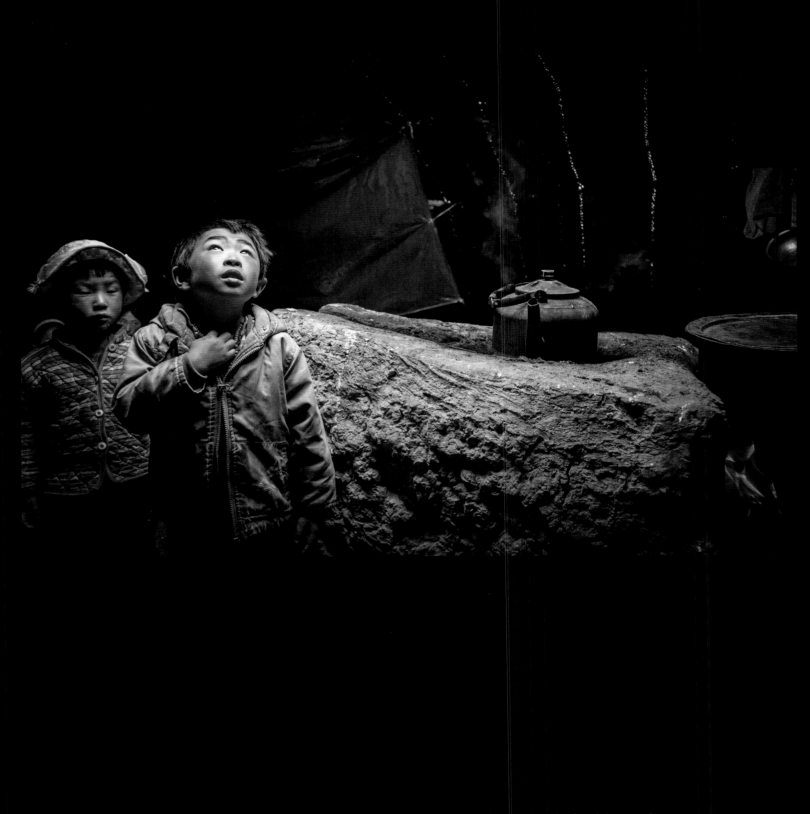

Demtso's youngest children, Chozang Norbu and his sister, by the clay stove at the family's nomad camp.
Lalung Valley, Nangchen, Kham, 2014.

The bright oldest children were already going to university – one in Xining and one in Chengdu – and it seemed highly unlikely that they would return to full-time nomad life.

After milking it was time for a breakfast of *tsampa* (ground roasted barley flour) and butter tea, a break before Demtso processed the dri milk to make butter, cheese and yoghurt. The herd is also milked in the evening in summer, so the family often eat supper after dark at this time. During the day, as well as cooking and looking after the youngest children, Demtso also collects water from the nearby stream, says her prayers in a quiet moment, spins wool, plaits ropes from yak hair and feeds the mastiff guard dogs. The family also collect plants together from a nearby valley for some of the Gebchak nuns to make into incense.

Until a few years ago, in the colder winter months the family lived in a wood and mud house a few hundred yards above their black tent. Now it needs repairing and, as wood is costly – and also hard to come by in Nangchen, a less forested area – they decided it was cheaper to buy a prefabricated metal house for winter use.

I went to the nomad camp twice, visiting again in August 2016. The first time, the family still cooked and heated their tent by means of a clay stove that traditionally would be built at the beginning of each new season. Clay is an efficient material for a stove, holding the heat well; in fact, I was told that even left unattended a clay stove can hold heat for up to two days. At the end of each season, the stove would be abandoned, biodegrading back into the land, and it was fascinating to hear from Wangdrak Rinpoche how Tibetan nomads traditionally treated the stove with a lot of respect. The second time I visited, a metal stove, portable and light to carry, had replaced the beautiful and sculptural clay stove; a shame, as I know now from experience that metal houses and metal stoves cool down very quickly and are not at all efficient at holding heat.

However, the family still use the black yak-hair tent that they will have woven themselves – warm, windproof and yet well ventilated – which creates perfect conditions for the production of butter, cheese and yoghurt.

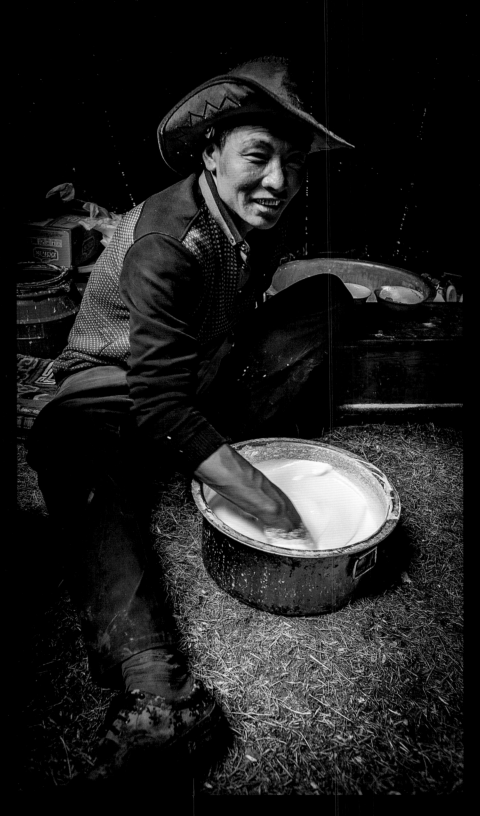

Demtso's brother-in-law, Digpo, in the final stages of butter making. Lalung Valley, Nangchen, Kham, 2016.

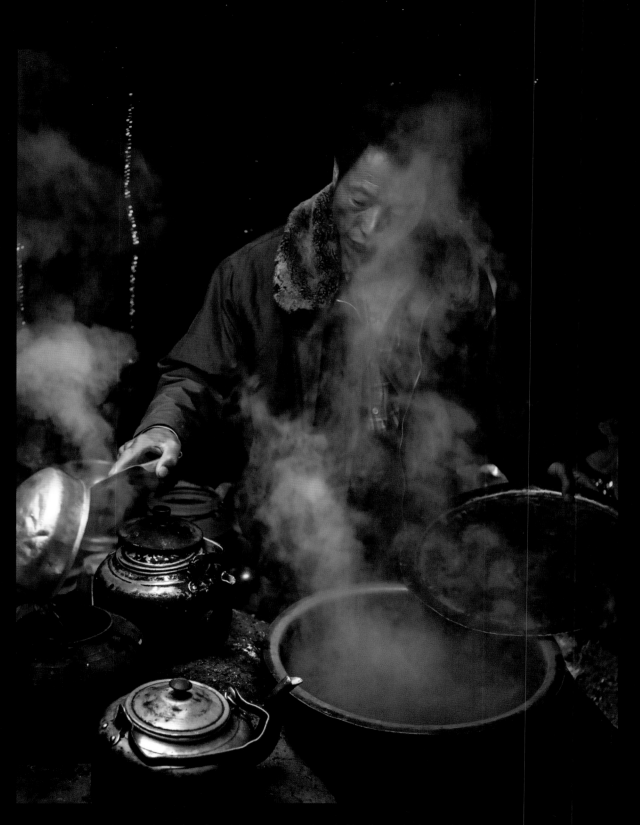

Rabten, Demtso's husband, making tea in the family black tent. Lalung Valley, Nangchen, Kham, 2014.

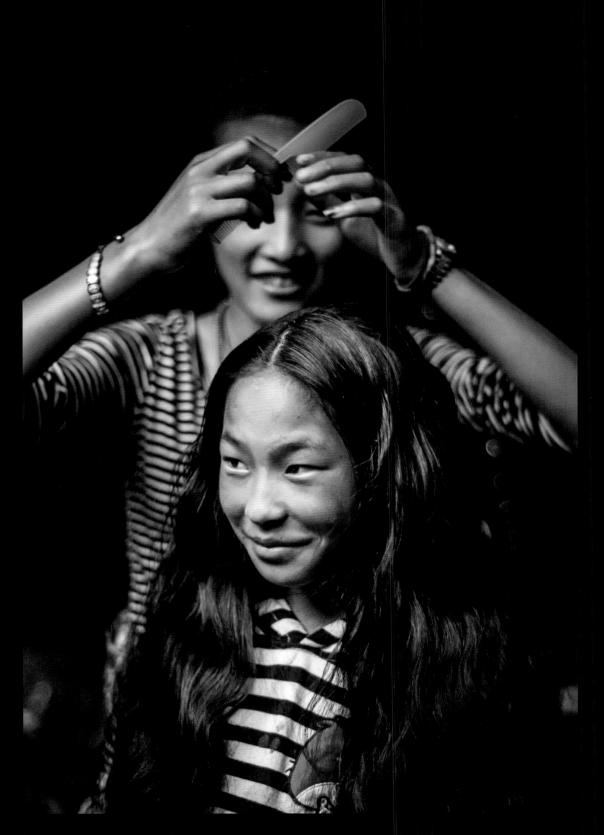

Dawa Lhamo combing her cousin's hair at a nomad camp of the Dong Tsang clan. Lalung Valley, Nangchen, Kham, 2016.

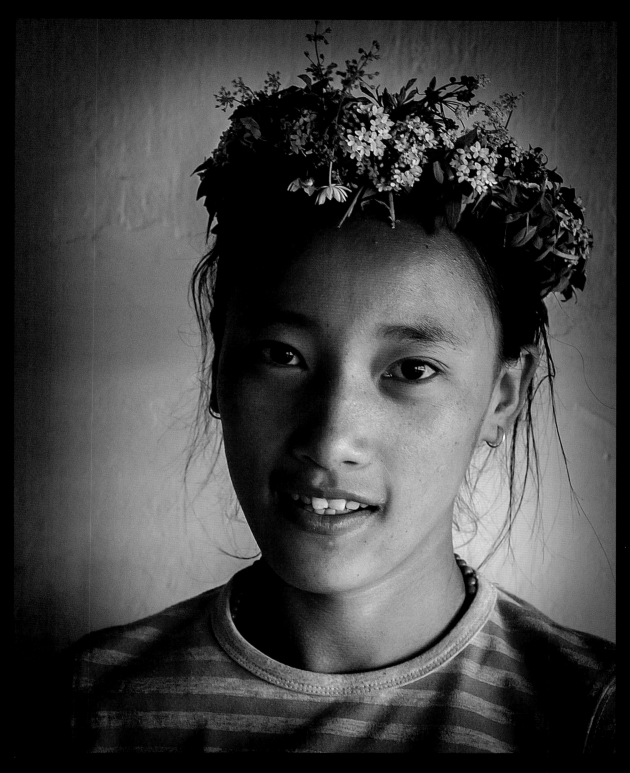

Wangdrak Rinpoche's niece Dawa Lhamo wearing a circle of grassland flowers. Dong Tsang Ritro hermitage, Nangchen, Kham, 2016.

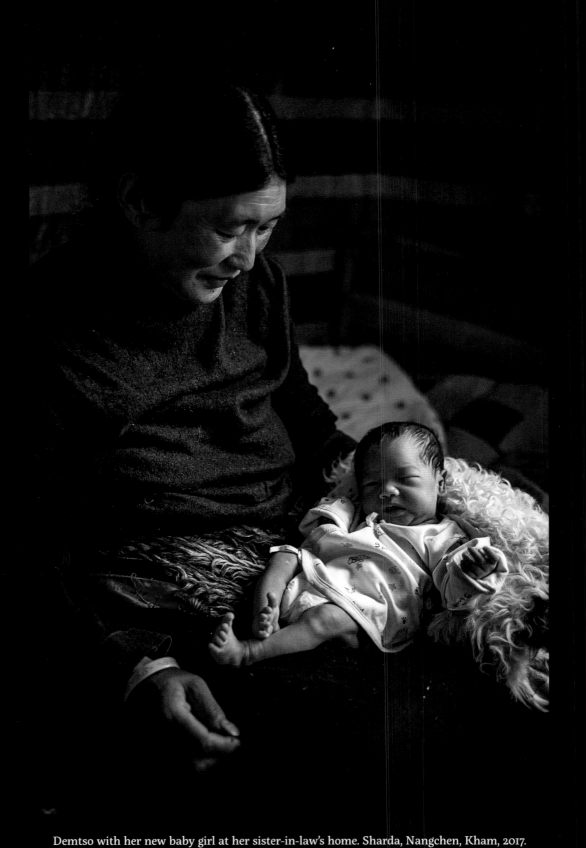

Demtso with her new baby girl at her sister-in-law's home. Sharda, Nangchen, Kham, 2017.

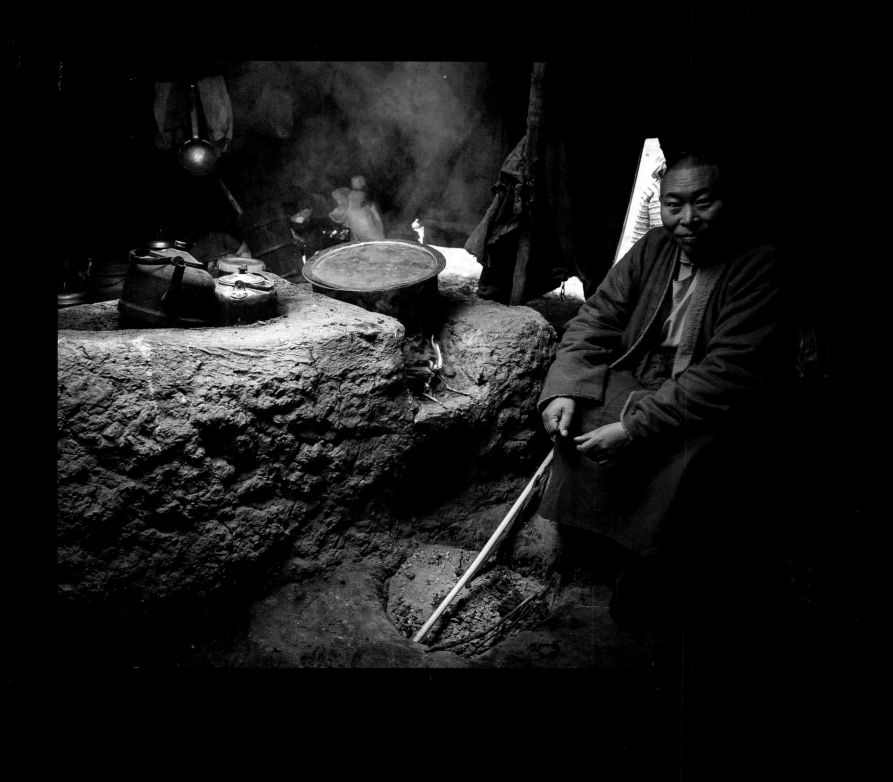

Wangdrak Rinpoche relaxes by the clay stove in his brother Rabten's nomad tent. Lalung Valley, Nangchen, Kham, 2014.

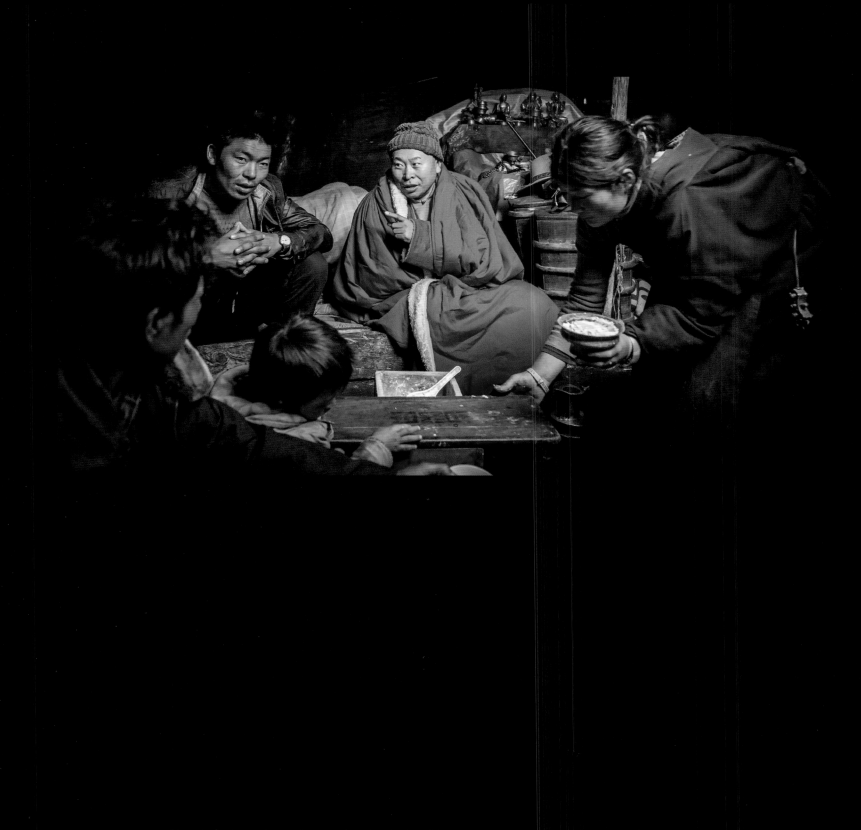

Wangdrak Rinpoche and his family relax for breakfast after early morning milking at their nomad camp.
Lalung Valley, Nangchen, Kham, 2014.

A lot of Tibetan traditions, especially among the nomads, are out of respect and devotion. For example, when you serve tsampa into your bowl from the container, the tradition is that you put the best of it back, for others to take.

It's always a Buddhist practice in these traditions. With the tsampa, the other people who eat it might be good or bad people, but regardless we are giving it back for others. And with tea, we offer it to the Lha – the Buddha, the deity. We are always offering to others.

Gebchak Wangdrak Rinpoche

THE GEBCHAK NUNS

The Tibetan calendar is full of religious festivals: *pujas* involving prayer, ritual music, offerings and sacred monastic dances known as *cham*. They commemorate the deeds of the Buddha or of great masters of the past associated with Bon or Buddhist traditions and celebrations can last for days, with the festivals generally culminating in empowerment or blessings from the officiating lamas. In many areas of Tibet the monks or nuns involved in these festivals would have been drawn from the local, largely nomadic, communities.

One of the festivals I attended in Tibet was the annual Monlam (or prayer festival) organised by the Gebchak nuns and held at Jamar Mani in the Nangchen area of Kham. Gebchak's remarkable and humble nuns undertake Tibetan Buddhist yoga and meditation practices from a young age and many become, in a most understated way, highly realised and accomplished yoginis.

The Monlam lasts for a week and is an important annual event for the nuns, as well as for the local nomadic people, who throng the remote area during that time.

Chozom and I accompanied Wangdrak Rinpoche to Jamar Mani for the Monlam and found the relatively newly constructed temple, made of concrete, was freezing, so while Rinpoche and Chozom spent the week inside I spent the week circumambulating the temple and the wall of mani stones with the pilgrims, taking photos. I was fascinated by groups of local youngsters wearing their finest clothes and shyly flirting with each other and experienced the simple happiness of walking in the October sunshine, absorbing the atmosphere of faith as people of all ages (mostly women) made prostrations or whispered mantras while performing their *kora*.

The female is like the earth, like the elements;

Like the earth, it is the basis for all qualities.

From the Heart Essence of the Dakinis, known in Tibetan as the Khandro Nyingtik

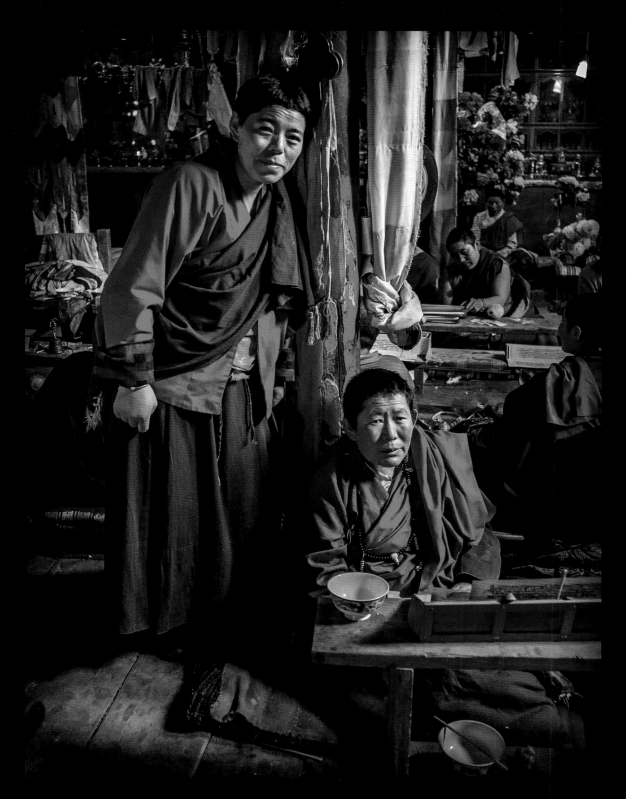

Gebchak nuns in a break from their daily *puja*. Gebchak Gonpa, Nangchen, Kham, 2017.

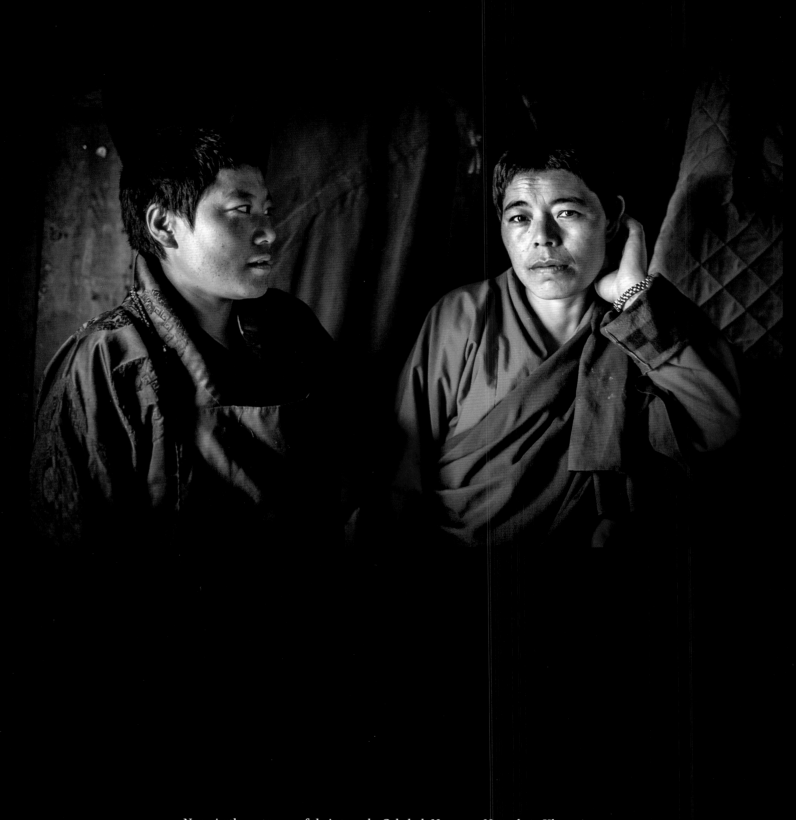

Nuns in the entrance of their temple. Gebchak Nunnery, Nangchen, Kham, 2017.

The basis for realising Enlightenment is a human body. Male or female, there is no great difference. But if she develops the mind bent on Enlightenment, the woman's body is better.

Padmasambhava, Guru Rinpoche, to his foremost student, the Lady Yeshe Tsogyal

In the mountains there is an open market,

Where the things of this world

Can be bartered for wisdom and bliss.

In the monastery of your heart and mind

lies a temple where all the Buddhas unite.

Milarepa

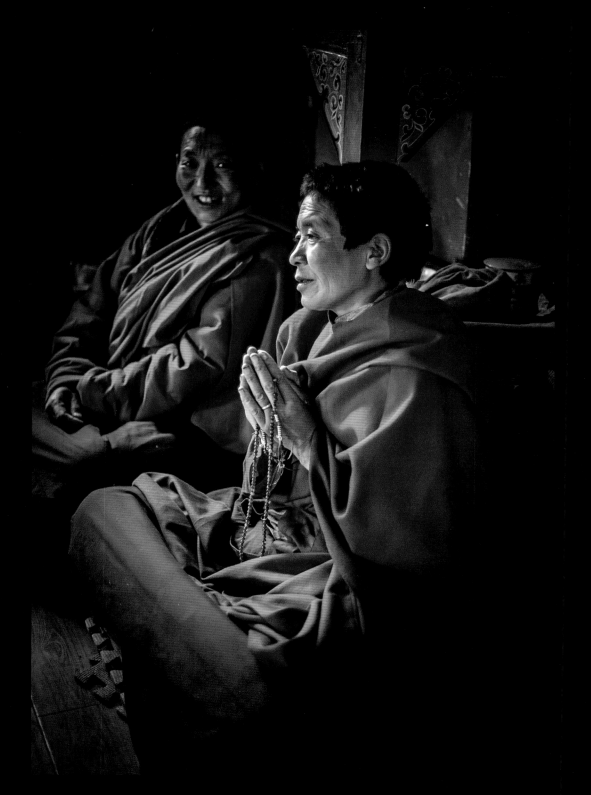

Gebchak nuns in prayer at their annual week-long Jamar Monlam (prayer festival). Jamar Mani, Nangchen, Kham, 2014.

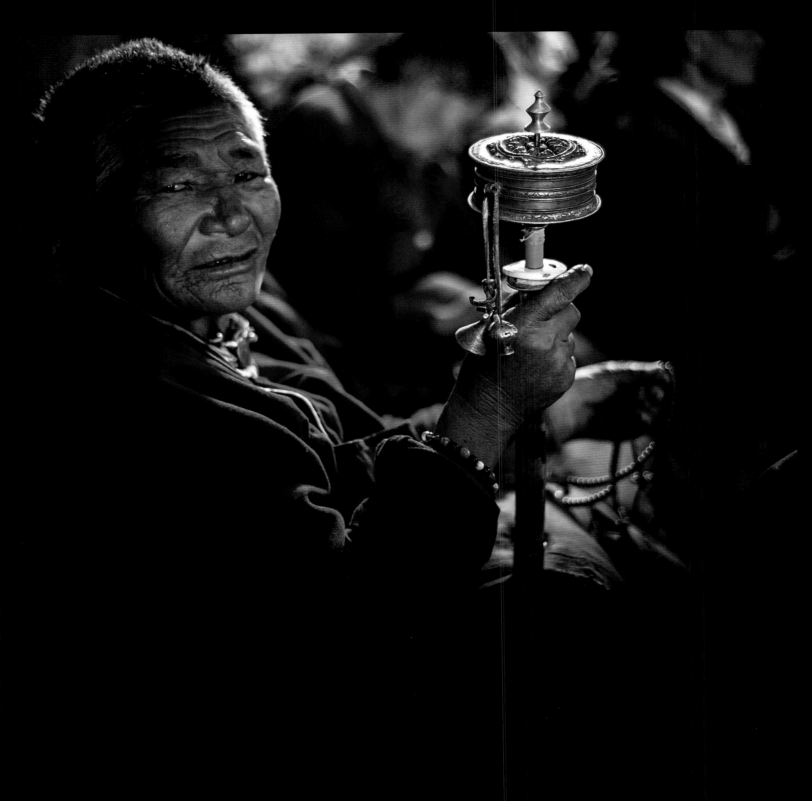

Prayers and mantras at the annual Jamar Monlam. Jamar Mani, Kham, 2014.

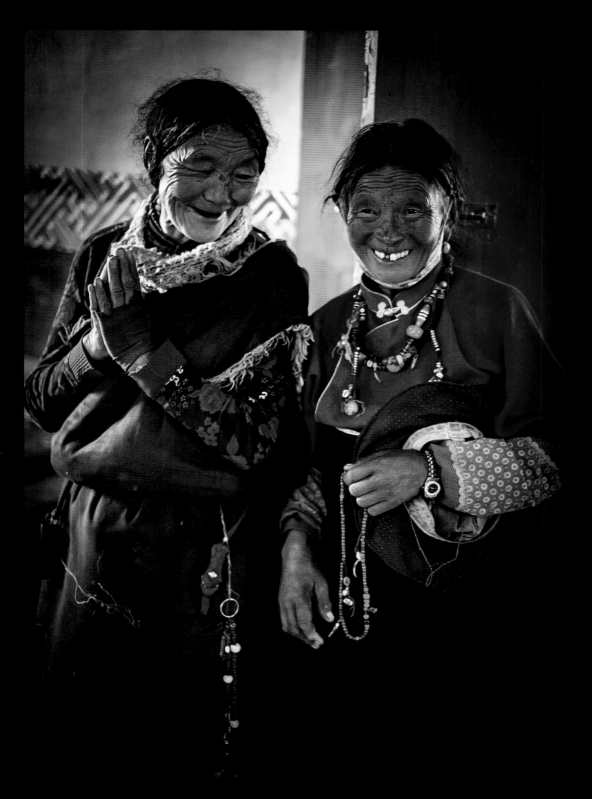

Local elders at the Jamar Monlam. Jamar Mani, Nangchen, Kham, 2014.

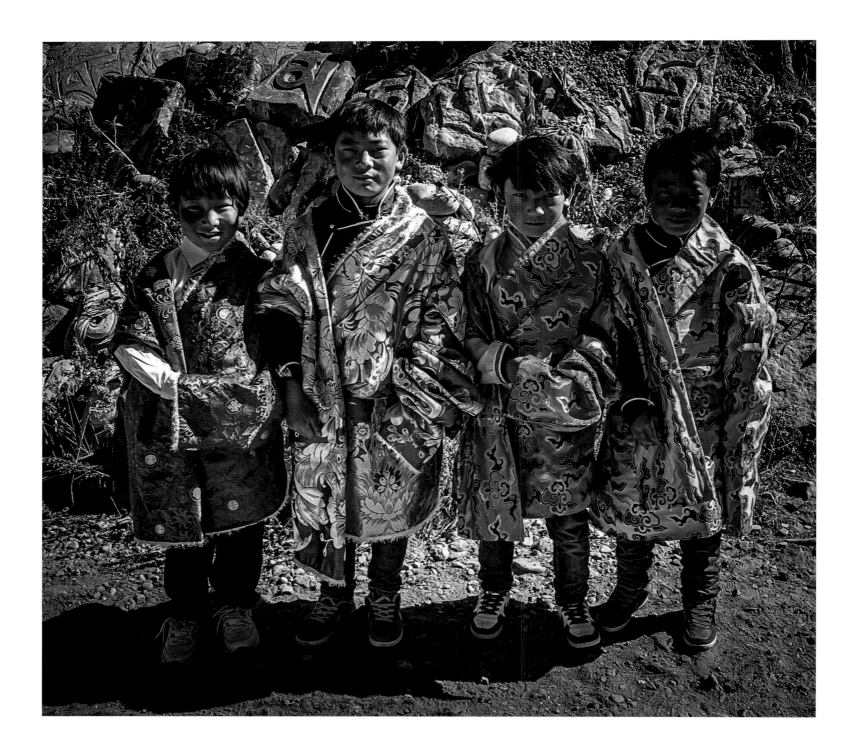

Fledgling Khampa warriors wearing their best clothes at the Jamar Monlam. Jamar Mani, Kham, 2014.

Folk song for a child:

On the tall snowy peaks,
The little lion cub is playing.
Oh you mountains, please be gentle,
Till the cub has grown his mane.

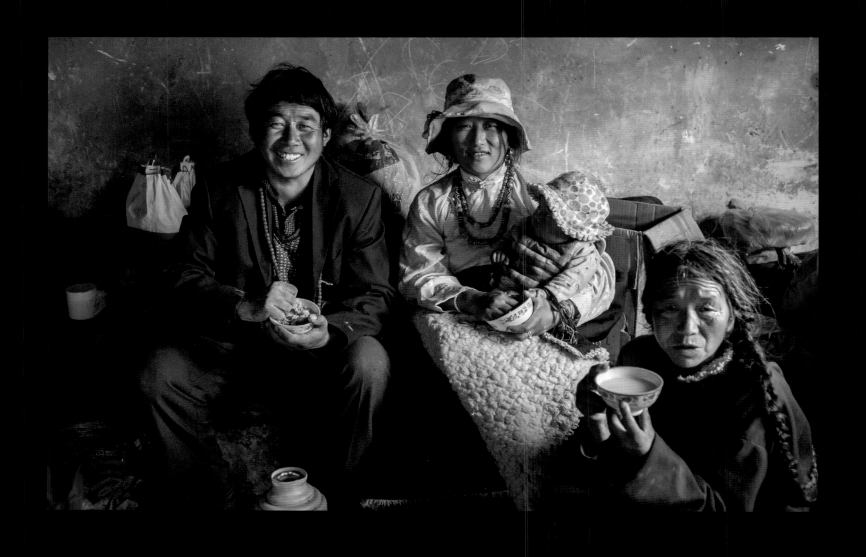

Local devotees take a lunch break at the Jamar Monlam. Jamar Mani, Nangchen, Kham, 2014.

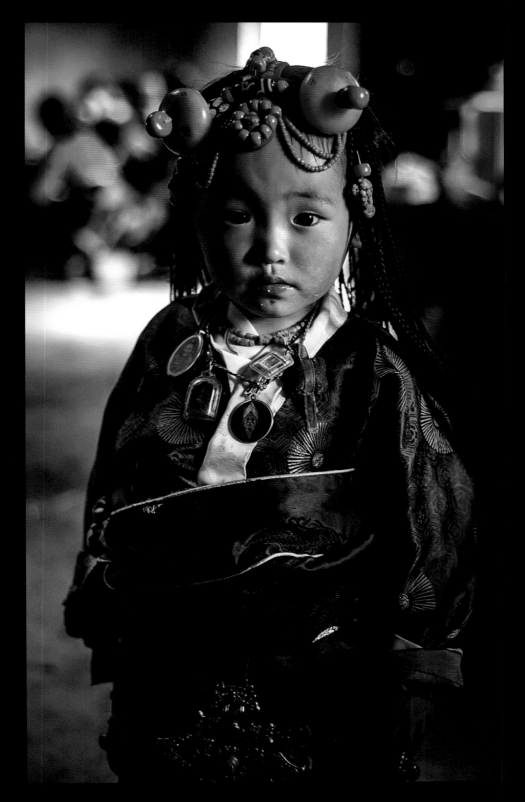

Little pilgrim at the Jamar Monlam, 2014.

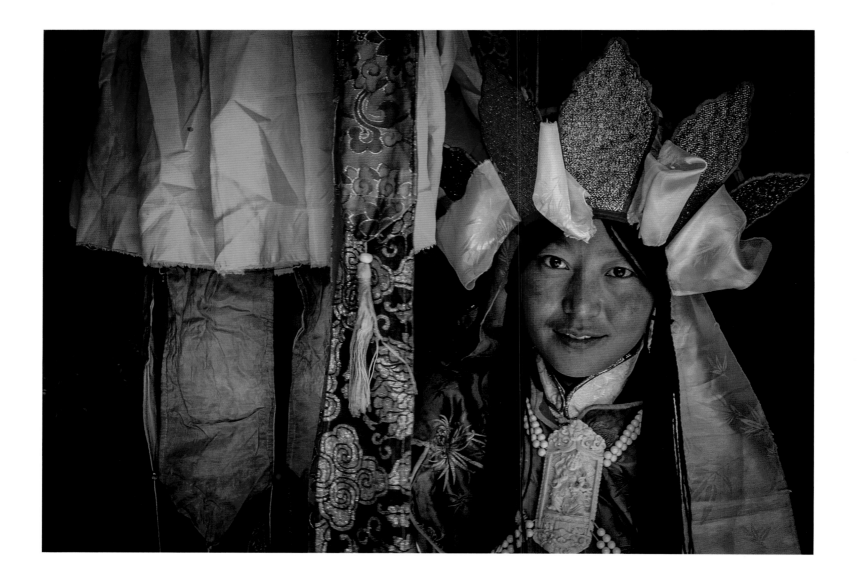

A Gebchak nun dressed as a dakini at the Jamar Monlam. Jamar Mani, Nangchen. Kham, 2014.

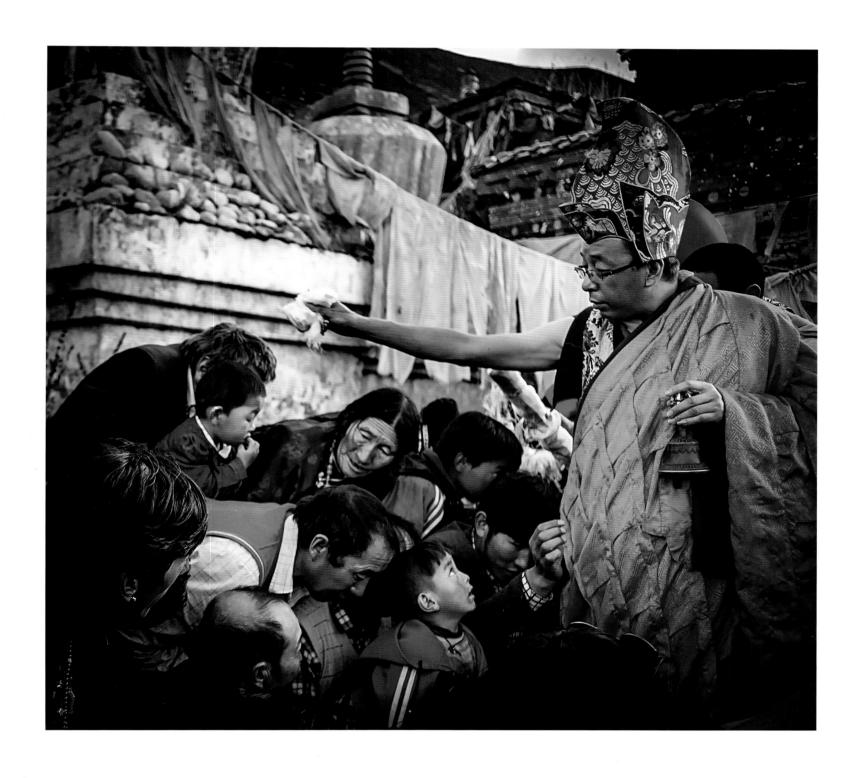

Tsangyang Gyamtso, a reincarnation of the founding lama of Gebchak Nunnery, blesses lay devotees at the end of the Jamar Monlam, 2014.

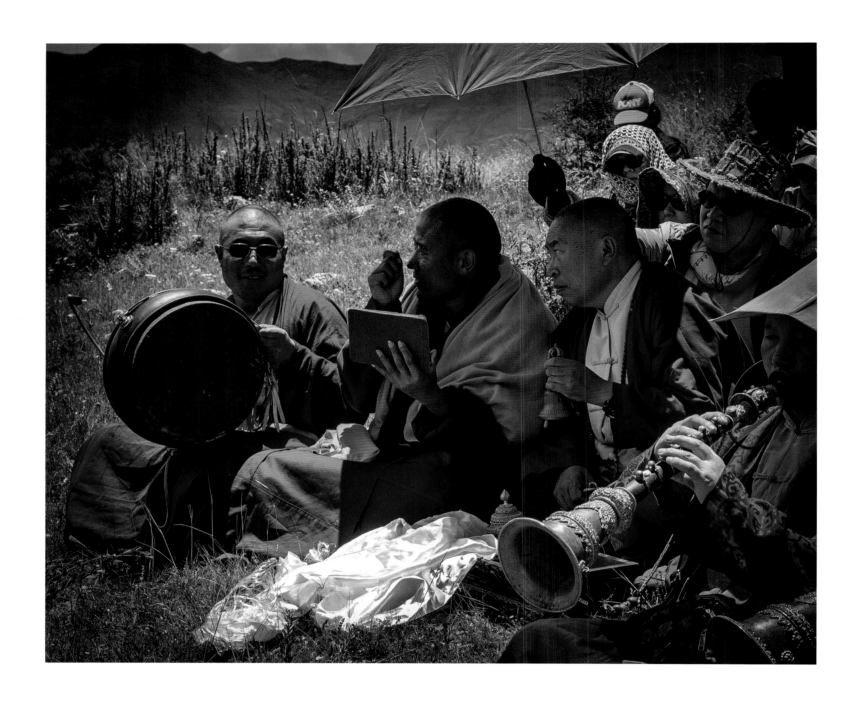

Wangdrak Rinpoche conducts a prayer ceremony for his Singapore students on the mountain above his meditation hermitage. Khenpo Karma Donden is reading the text of the ceremony from his iPad.
Dong Tsang Ritro Hermitage, Nangchen, Kham, 2016.

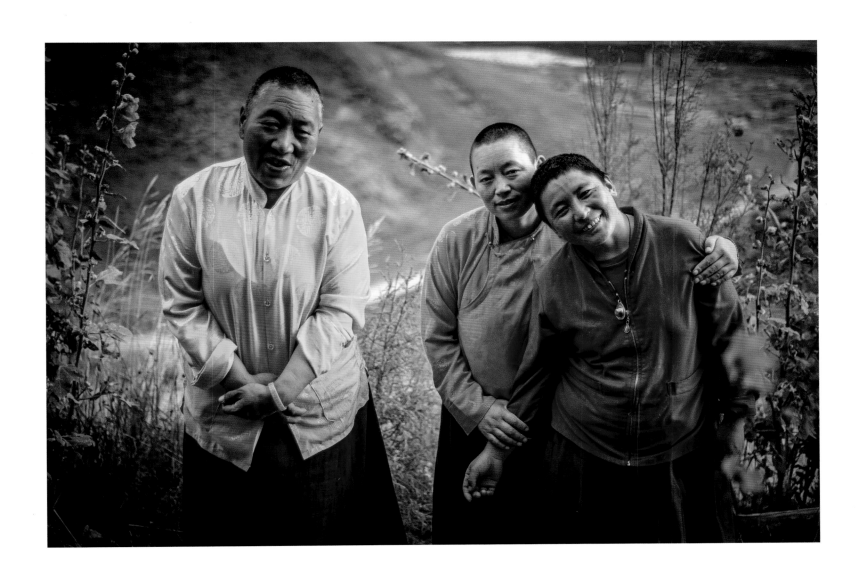

Ani Zopa and friends at Wangdrak Rinpoche's meditation hermitage. Nearly all the nuns at the hermitage are from Gebchak Gonpa, the mother nunnery of a wider community of nunneries in Kham. Nangchen, Kham, 2019.

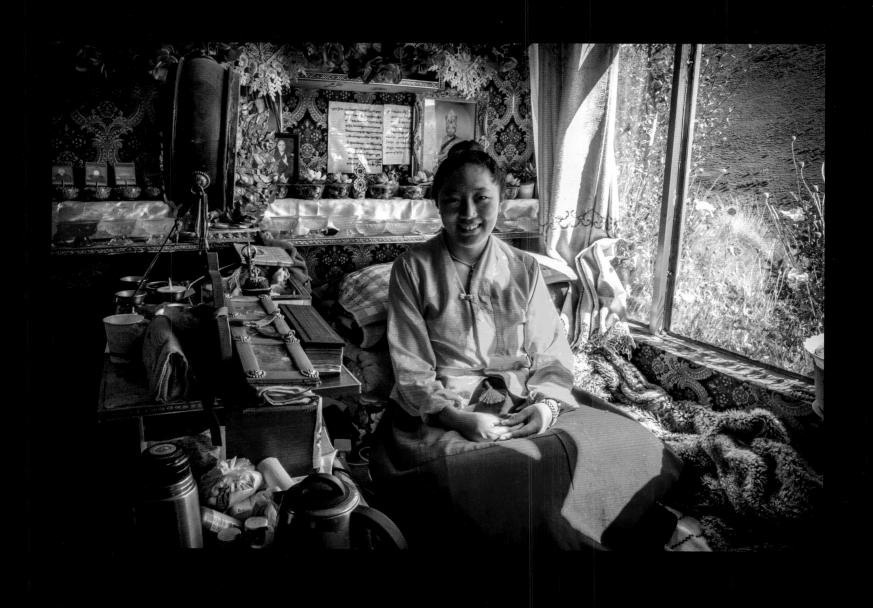

The nun and fledgling yogini Ani Tenzin Yangchen in her room at Dong Tsang Ritro hermitage. Yogic practitioners often grow their hair out during prolonged retreat periods of Tsa Lung practice. Nangchen, Kham, 2019.

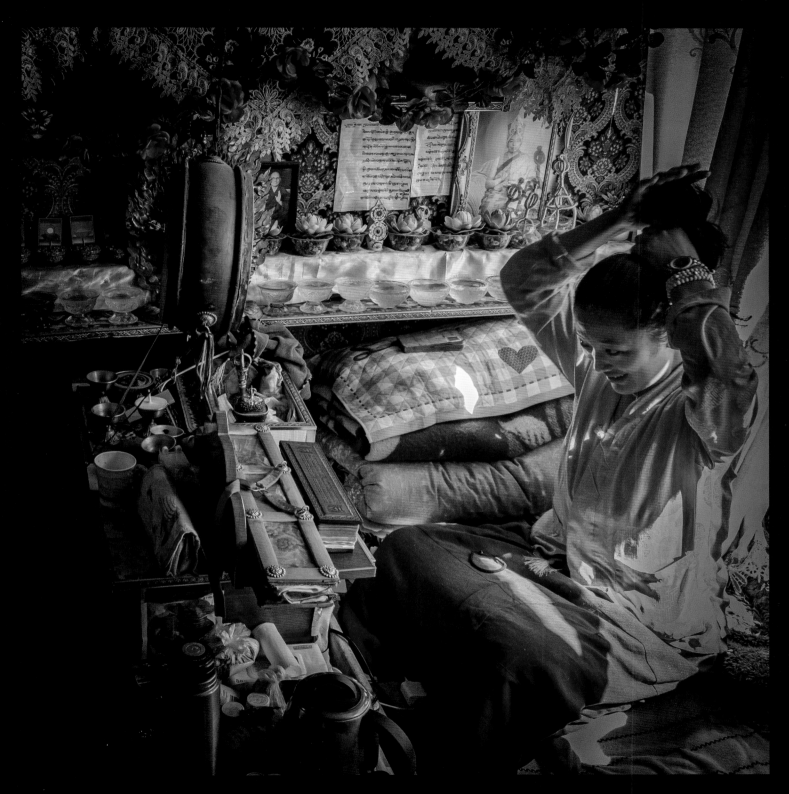

Ani Tenzin Yangchen ties up her long hair. Dong Tsang Ritro hermitage, Nangchen, Kham, 2019.

JOURNEYS WITH DAWA

All my subsequent journeys in eastern Tibet from 2015 to 2019 have involved travelling with my old friend Dawa, a university-educated farmer's son married to Lhaden, who is from a nomad family. They now live in the busy and burgeoning town of Kandze, together with their two children. For some years Dawa has been my guide, translator and dharma brother. We first met in Dzongsar in 2006, and first travelled together in 2009, at that time mostly by bus. It was in that year that we both first met Wangdrak Rinpoche and a friendship was forged between the three of us.

By 2015 Dawa had a four-wheel drive vehicle which, with the new roads and tunnels, has enabled us to weave with ease back and forth across Kham and parts of Amdo every year, visiting his friends and dropping in on picnics, horse and monastery festivals, sacred lakes and yogi's caves. We moved from stunning alpine meadows and snowy mountains to rolling high-altitude grasslands, from boggy marshes to desertified areas, from busy and growing towns to beautiful and deserted valleys lined with limestone and sandstone cliffs. We made our way on sophisticated highways, dirt roads, barely discernible tracks and across grassy meadows and trackless, snow-covered plains. If the vehicle could go no further to the nomad camps of Dawa's friends, they would meet us with horses or motorbikes, which was sometimes a little scary – travelling on the back of a motorbike up a dried glacial stream bed at 15,000 feet.

It has been an incredible way to get a feeling for the land and its people – though I would still say that travelling on horseback is my favourite method of getting around in eastern Tibet.

Knowing that I was curious to see how nomads put up their magnificent black tents, Dawa introduced me to his friend Yeshe Tsering, who invited me to accompany his family as they moved to their summer pastures in Ramashong Valley, Kham.

I somehow imagined that Dawa and I would follow them by the nearby road, but, unprepared, I found myself on horseback, roped into helping Yeshe Tsering's wife Palmo, and one of their daughters move the yak herd to the new pastures. I was astonished to discover skills I didn't know I had in guiding stray dri with their babies to rejoin the herd. Halfway through the long day I dismounted and was sent off on the back of Yeshe Tsering's motorbike to the new camp in order to record the erection of the black yak-wool tent and also their canvas tent. The yak-wool tent arrived on the back of a big male yak while the canvas one was piled, along with cooking pots, bedding, clothes and other necessaries, onto a small three-wheeled truck. The rinpoche of their community, from a nomad family himself, is encouraging all the families to return to using black tents. By the time Palmo arrived with the herd it was evening time, the tents were up and the stove was lit.

During one of my visits to Chengdu, I met Dawa's old friend Palsang, who happened to be passing through. He is a remarkable, university-educated nomad who had been working for an NGO supporting Tibetan projects and invited us to visit the nomad camp of his family in the Ma Chu (Yellow River) area of Amdo.

Seeing the desertification in his area, brought about by open-cast mining techniques and exacerbated by global warming, Palsang had been moved to start a regreening project locally.

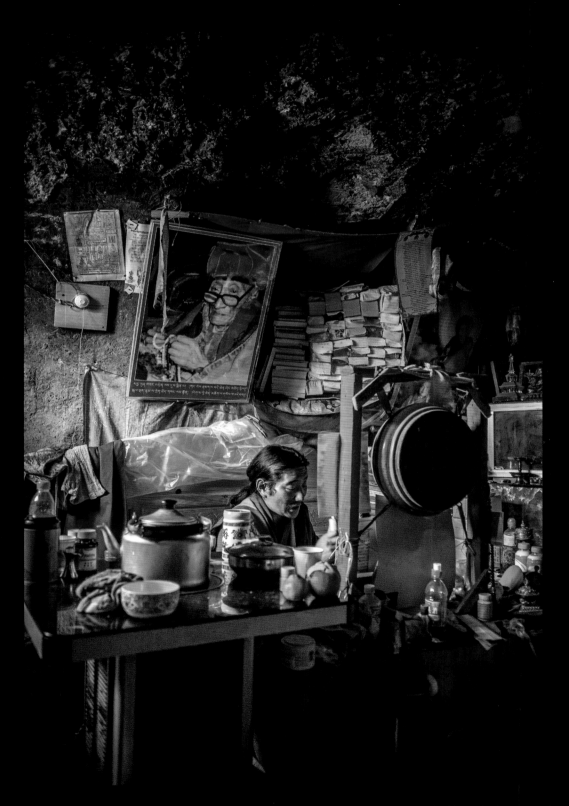

One of the caves used by the great Dzogchen master Patrul Rinpoche. Mamo Thang, Sershul/Dzachuka area, Kham, 2019.

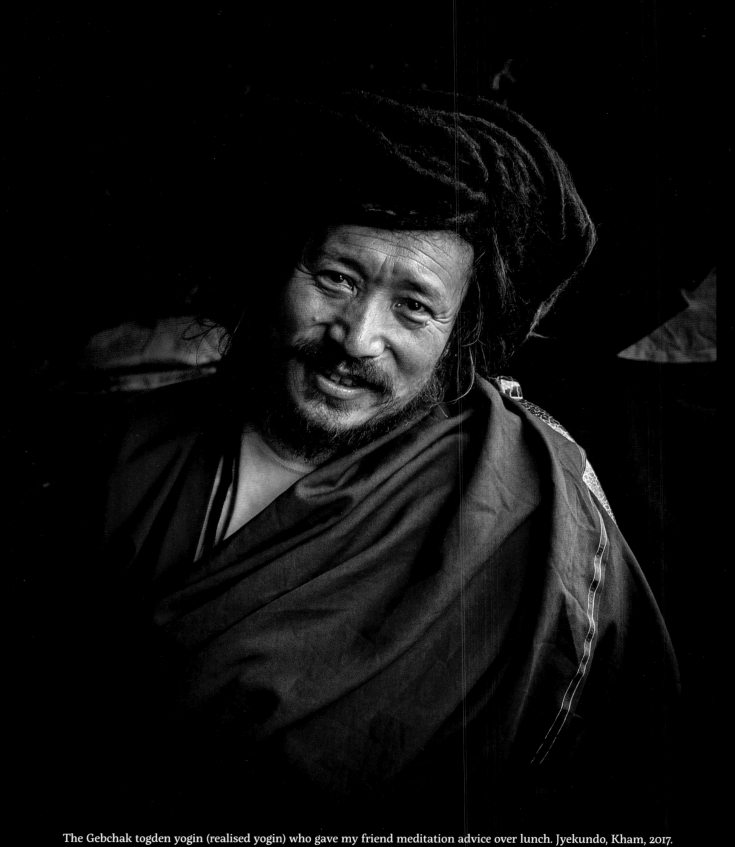

The Gebchak togden yogin (realised yogin) who gave my friend meditation advice over lunch. Jyekundo, Kham, 2017.

Perfectly stay in the natural flow,

There is no other concentration.

Perfectly realize the natural state,

There is no other wisdom.

Patrul Rinpoche in The Words of My Perfect Teacher

This was supported by nomad volunteers and has been very sucessfulful; so successful, in fact, that a TV programme has been made about him in China in which he was characterised as the Hero of the Grasslands.

Palsang's strategy was simple and very Tibetan: teams of local volunteers (promised a good feast once the work was completed!) would plant local grass seed in furrows in a large fenced-off area of what were essentially sand dunes. A herd of yak and dri would be driven into the area overnight for a few weeks, trampling the ground and adding their dung to the mix. Meanwhile, Palsang had collected offerings from the community and visited the local monasteries to request Naga *pujas* – prayer ceremonies to bring about rain. By all accounts, the combination worked! He told me that some of his ideas had developed from listening unobtrusively to nomad women discussing what they thought would help make the project work. I was moved by the respect he had for all the women folk and their ideas and struck by how he wanted to encourage talented young people to stay in his area, countering the drain of the gifted to the cities.

Dawa's friend Gyaltso, a nomad from Mamothang Valley who has settled and is living with his wife and son in their winter quarters, introduced us to several nomad families in Sershul area. Understanding my interest in nomad culture, he went out of his way to lead us to young Drokpa families

still proudly living in yak-wool tents, very traditionally and beautifully arranged, with shrines with thangkas and yak-skin bags for storing butter, *tsampa* and dried cheese. We met Sengko, whose black tent he had woven himself, and in which he had the most beautiful and sculptural traditional clay stove, created for him by Gyaltso. On one freezing winter visit, Gyaltso also took us across trackless snowfields to Dona *rukor*, where the nomads still live in tents in the winter, and to friends close to his home whose winter quarters are the very latest thing – metal prefabs. These affordable housing solutions, with their rapidly cooling interiors and the TV like a shrine to focus on, failed to win me over.

Travelling in eastern Tibet with Dawa, we have often visited his old friend Sonam Wangbo and his family: his wife, Pema Choezom, several children, his mother and his uncle. They are nomads who live in the remote, beautiful and sacred Dahu Valley. Until about fifteen years ago the family lived all year round in a tent, and then nomad families were encouraged to build permanent winter homes – in this region log cabins, as Kham still has some forests. They move between four different pastures in the area, staying in a canvas tent in the summer, a simple mud and wood home or a canvas tent in spring and autumn, and in winter in the cosy log cabin, where Uncle lives all year round.

The first time I visited we travelled on horseback for many bottom-aching hours to reach his spring home high in flower-filled pastures. On our arrival we settled in front of his stove with the Tibetan staple, a bowl of *tsampa*, listening to local gossip and stories being shared. Then, idly I found myself asking Sonam Wangbo if he had ever seen a dragon.

'Yes, in the high summer pastures a year or two back,' he said casually. Using his hands, he proceeded to describe how a dragon had descended, pushing a thick cloud down towards the mountain, and had then spiralled back up into the sky. He told us that his grandma saw one fleetingly too, in high summer pastures when she was young. He then moved on to the topic of a new road coming through the valley below and the impact it might have on him and his family. The dragons were forgotten. But not by me. The magic of the Dahu Valley (locally referred to as sacred, as serious yogi meditators have been known to practice in caves there), stunning in its alpine beauty and with its purple mountains, eagles cruising to nests high in the valley walls and tumbling glacial streams, made dragons seem entirely possible. Dragon stories (when I asked) were commonplace among nomad friends. This area is probably my favourite location in all of my travels, off the beaten track, so far unspoilt and unexploited, and yet relatively close to Dawa's ancestral village.

There was magic too in the warmth and simplicity of Sonam Wangbo's family life – I was constantly touched by the way his wife, Pema Choezom, would look at her children, how they liked to stay close to her when she was milking or to sit on their dad's lap when he was relaxing. I think this family sum up many things that have inspired me about the nomad lifestyle – warm, hardworking, simple and self-sufficient, hospitable, generous and with care and concern for their family, friends, neighbours and the grasslands they inhabit.

Loving them as I do, I worry about what the future holds for the Drokpa people. Due to the remote nature of the areas suitable for nomad life, their culture has so far survived, but there is a very real danger that the Drokpa could experience the same fate as other indigenous peoples due to the lack of value ascribed to their culture. But what I have always seen – and what I have tried to convey through my photographs – is the magic, the beauty and the mystical consciousness of a people in tune with spirit both inner and outer. I rather suspect that the Drokpa's self-sustaining, simple lifestyle of freedom lived in harmony with and respect for the land will survive and have much to teach us. I hope my photographs are a celebration of all that this culture embodies.

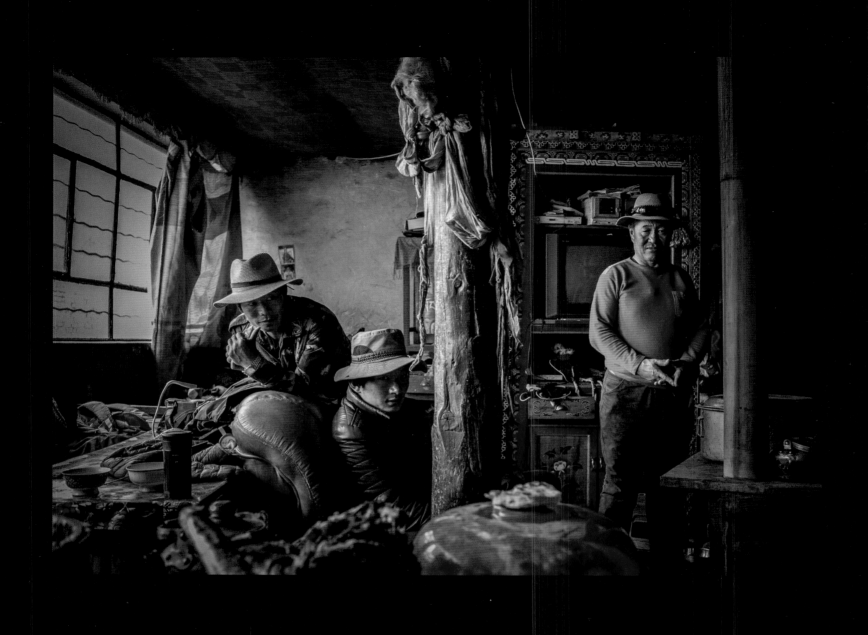

Khampa men, yogini Ani Tenzin Yangchen's family. Rakchen Nang Valley, Nangchen, Kham, 2018.

My nomad family live at very high altitude, maybe 200 or 300 metres higher than Gebchak

Nunnery, so in the summer when it rains at Dong Tsang Ritro it snows up there and is very

windy and cold. However, there are lots of beautiful flowers and plentiful grass and medicinal

plants grow abundantly there. So the yak always have enough to eat – they don't face a

problem with the yak not having enough grass [...] We knew that if we moved to town we'd have

to buy meat and dairy products and we wouldn't have anything to sell. If you don't have your

yak, you have nothing. We knew that the best thing was to stay as nomads as we have plenty

of what we need, and because it is so high-altitude it is very good for dairy production with the

yak. They don't sell any of it in town – it all goes to the family members. They are self-sufficient.

My family only slaughter yak in winter – about six a year – and it's mostly the older ones,

mostly males. They don't slaughter in the summer. They choose by age – for example, if a

dri is older and hasn't had children for some years, they will choose the dri, otherwise

mostly the males.

Ani Tenzin Yangchen in conversation with Tenzin Chozom

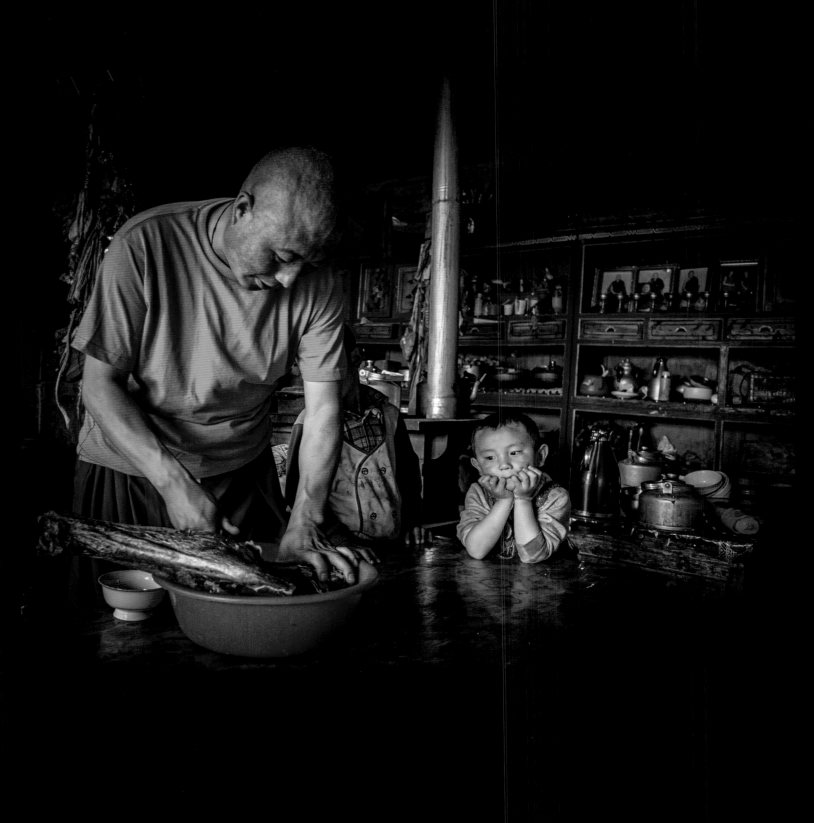

Above and page 87: Lama Chamchu Dorjee cutting up yak meat for us all as a snack with Tibetan flatbread.
At Ani Tenzin Yangchen's family's winter home. Rakchen Nang Valley, Nangchen, Kham, 2018.

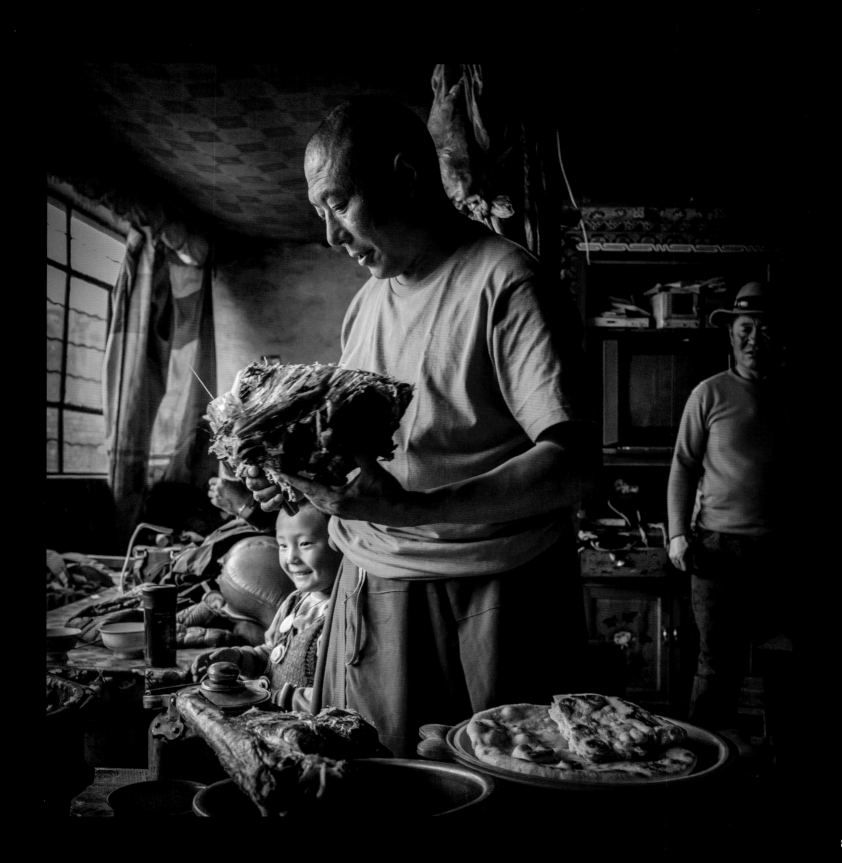

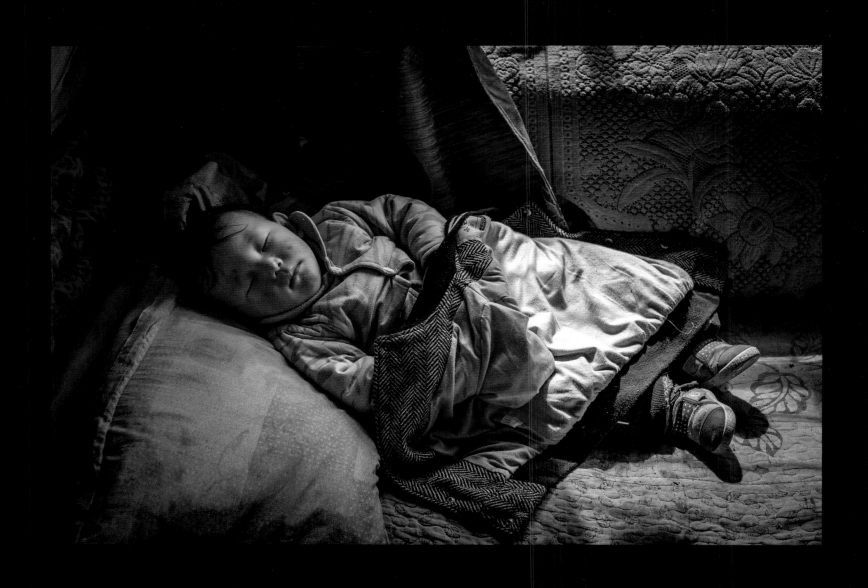

Ani Tenzin Yangchen's nephew sleeping. Rakchen Nang Valley, Kham, 2018.

With all its many risks, this life endures no more than windblown bubbles in a stream.

How marvellous to breathe in and out again, to fall asleep and then awake refreshed.

Nagarjuna, letter to a friend

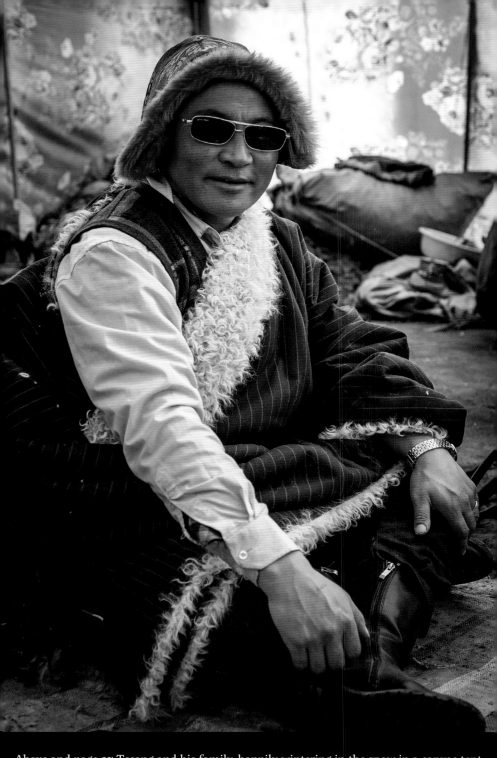

Above and page 91: Tesang and his family, happily wintering in the snow in a canvas tent. *Dong rukor*, Mamothang, Sershul/Dzachuka area, Kham, 2018.

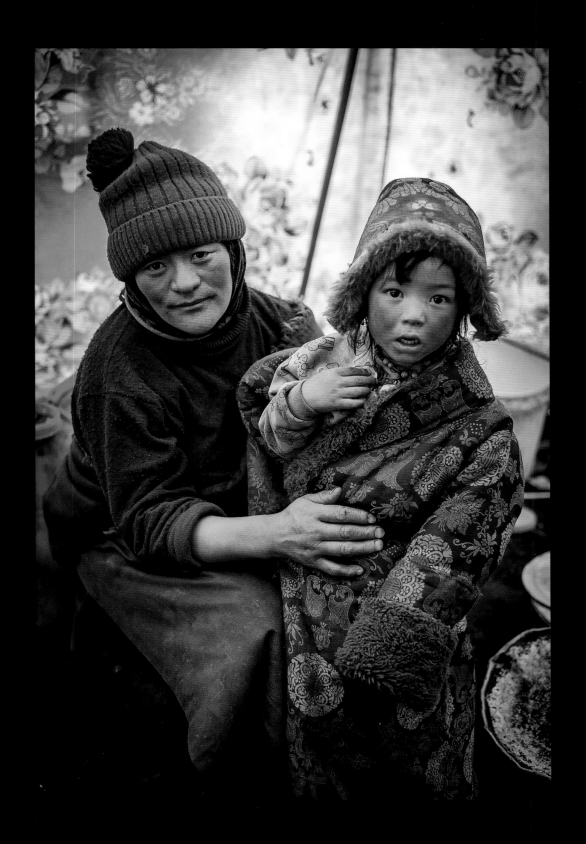

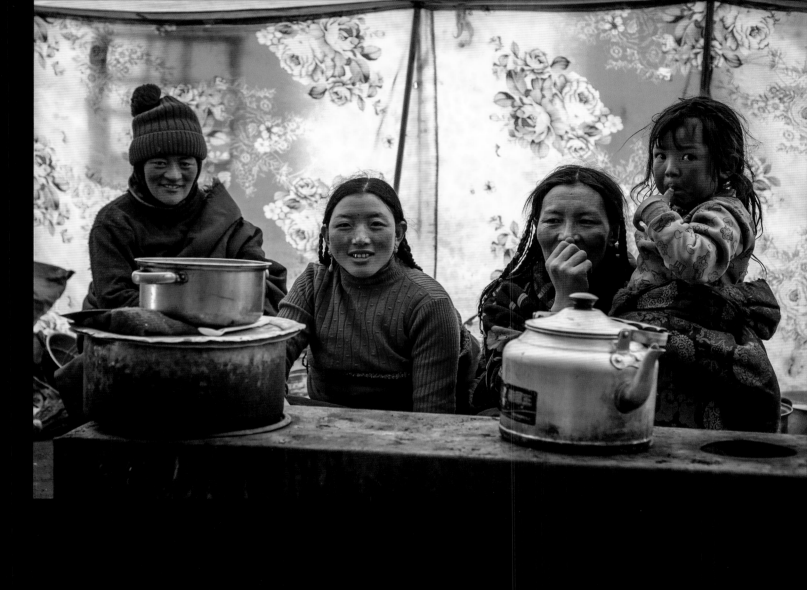

Above and page 93: Tesang's family spending winter in a canvas tent. In this *rukor* there were four families – two lived in black yak-hair tents and two in canvas tents. Many nomads lived in tents all year round until relatively recently, when they were encouraged to build winter quarters. Mamothang, Kham, 2018.

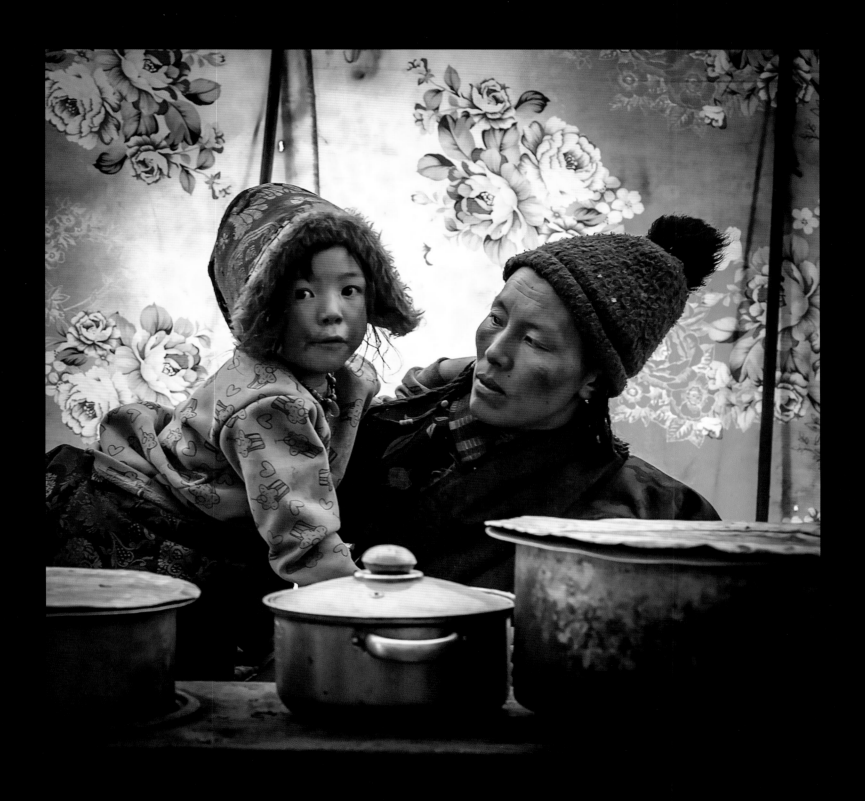

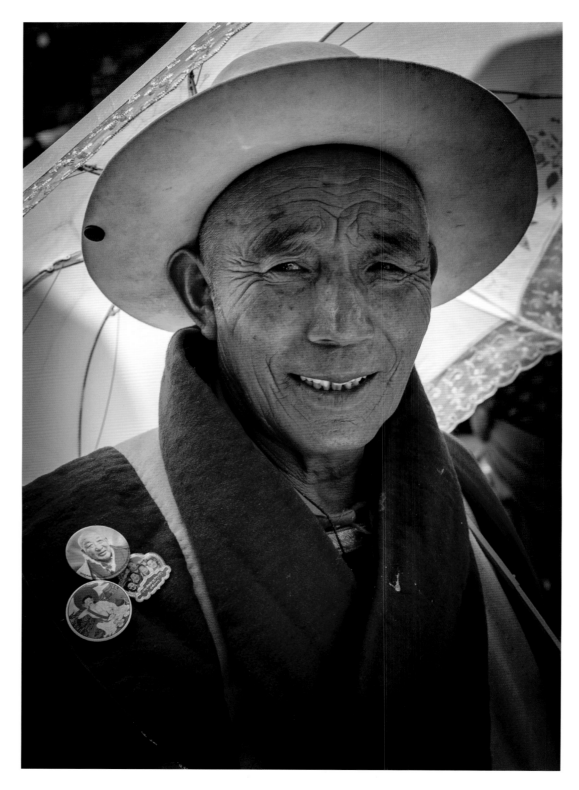

Lama at Lhasha Monastery Lama Dance Festival, near Manigengo, Kham, 2015.

If you have really assimilated the teachings properly, everything you do, say and think should be as soft as stepping on cotton wool and as mild as tsampa soup laced with butter.

Patrul Rinpoche

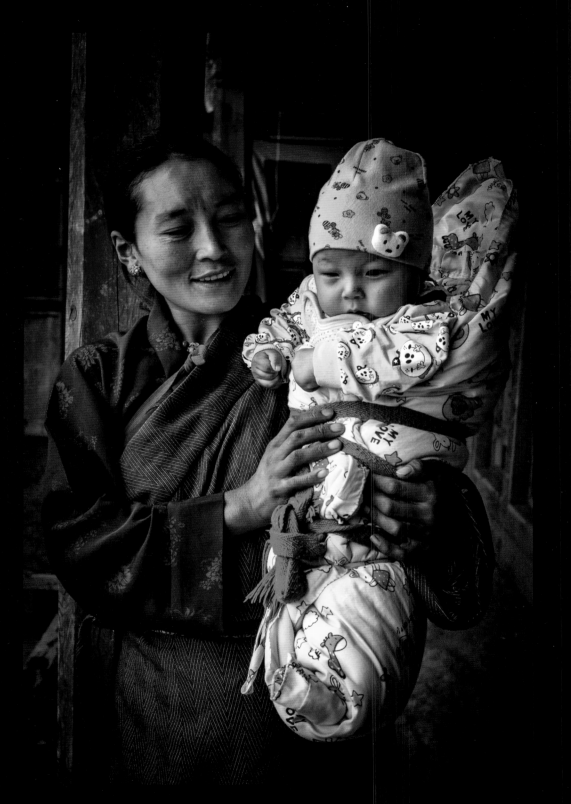

Proud mum at Longna Monastery Festival, Rongpatsa, Kham, 2015.

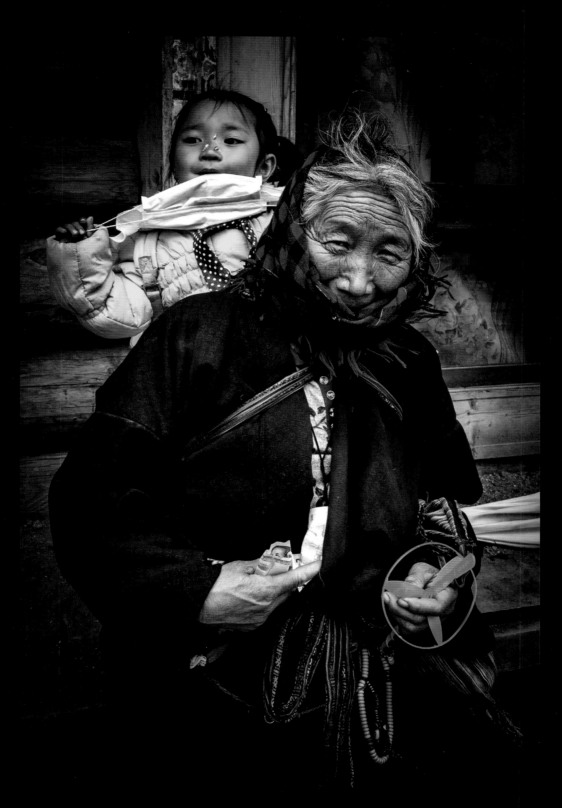

Local granny and grandchild at Longna Monastery Festival, Rongpatsa, Kham, 2015.

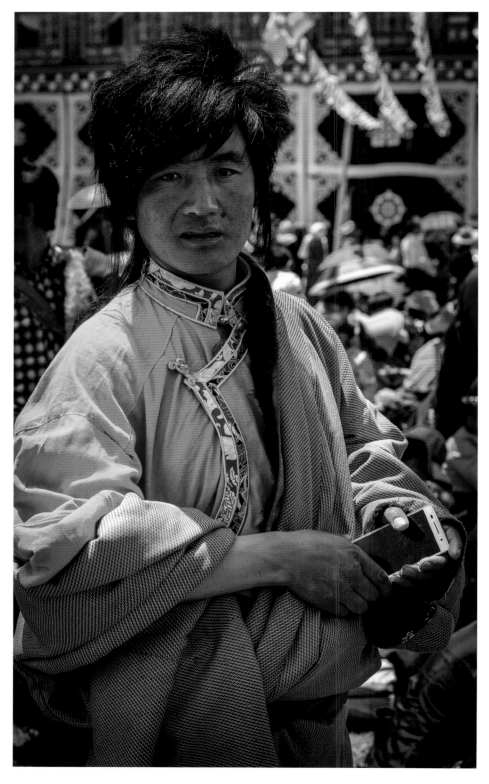

Men and phones at Lhasha Monastery Festival, Manigengo, Kham, 2015.

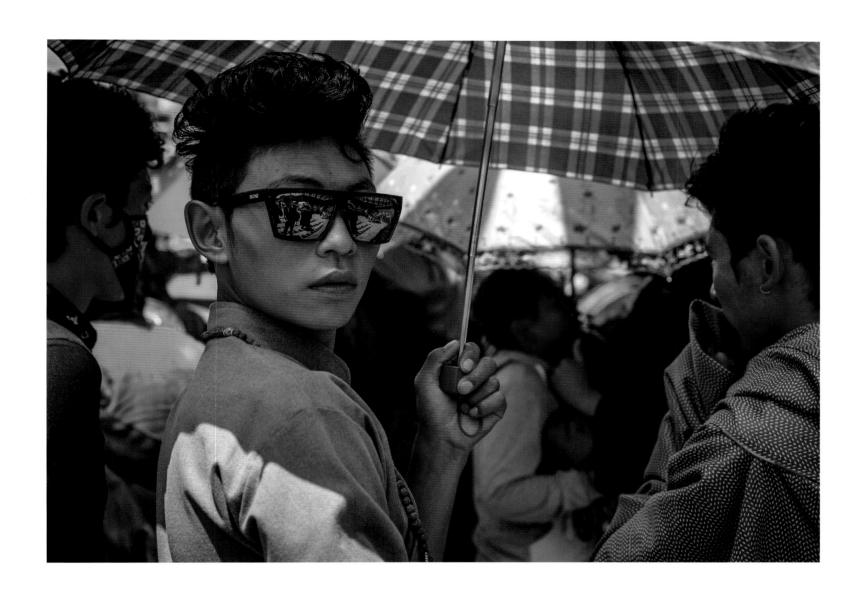

Young men with fancy hairstyles. Locally, the haircut of the boy above was laughingly referred to at the time as 'Chicken Head', while their clothes remain more traditional. Lasha Monastery festival, Manigengo, Kham, 2015.

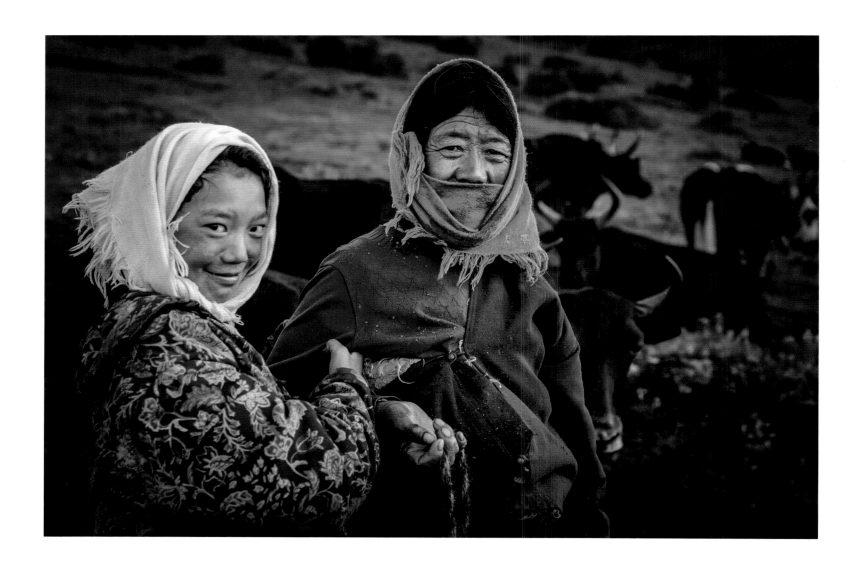

Grandma and granddaughter at milking time. Nomad camp near Rongpatsa, Kham, 2015.

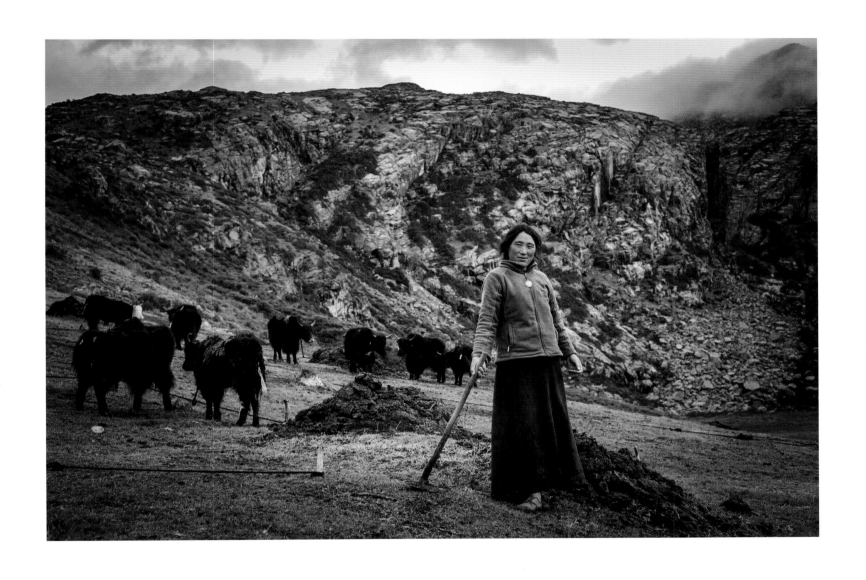

Yeshe Lhamo pauses while collecting yak dung in her family's high summer pastures – yak dung is the essential fuel for nomad stoves. Dahu Valley, Kham, 2017.

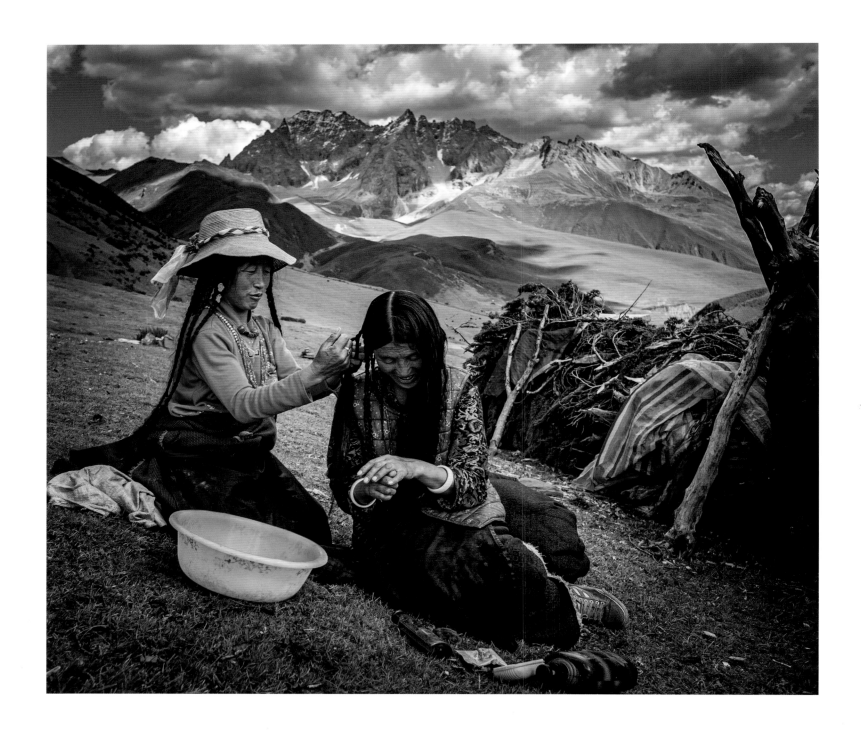

In a quiet moment at the family nomad camp, Palmo has her hair groomed by her sister. Traditionally, ladies in this area would have 108 plaits, a sacred number in Tibet. Ramashong Valley, near Manigengo, Kham, 2015.

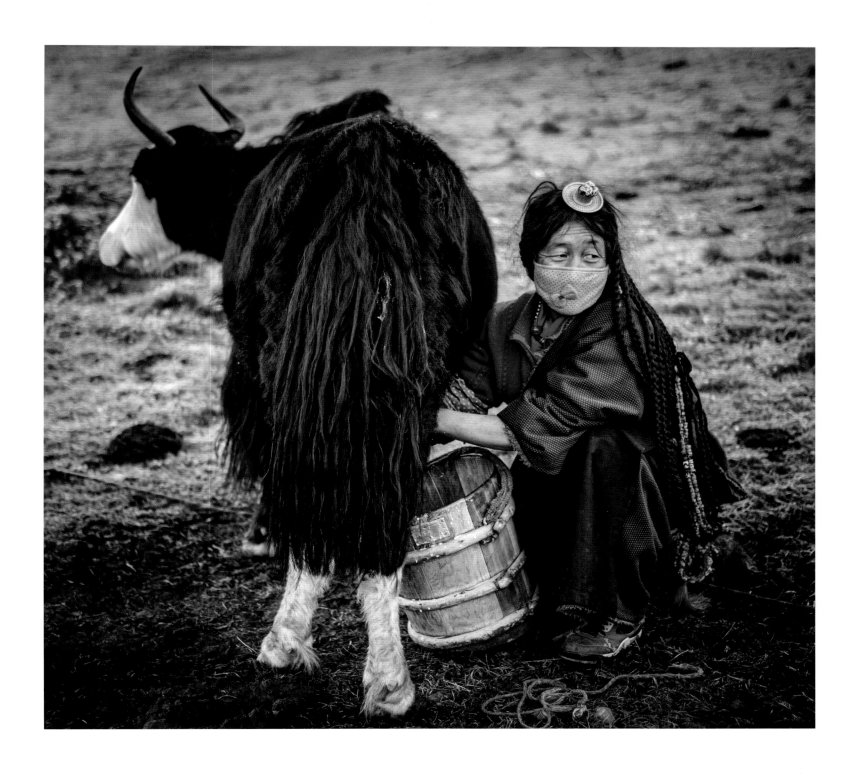

Palmo's sister at early morning milking. Even though it is July, the altitude (c. 14,000 feet) means that frost is common.
Ramashong Valley, Kham, 2015.

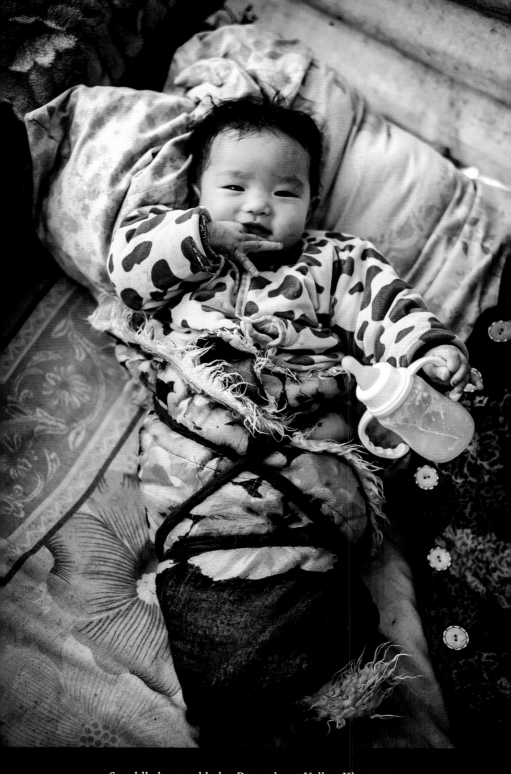

Swaddled nomad baby, Ramashong Valley, Kham, 2017

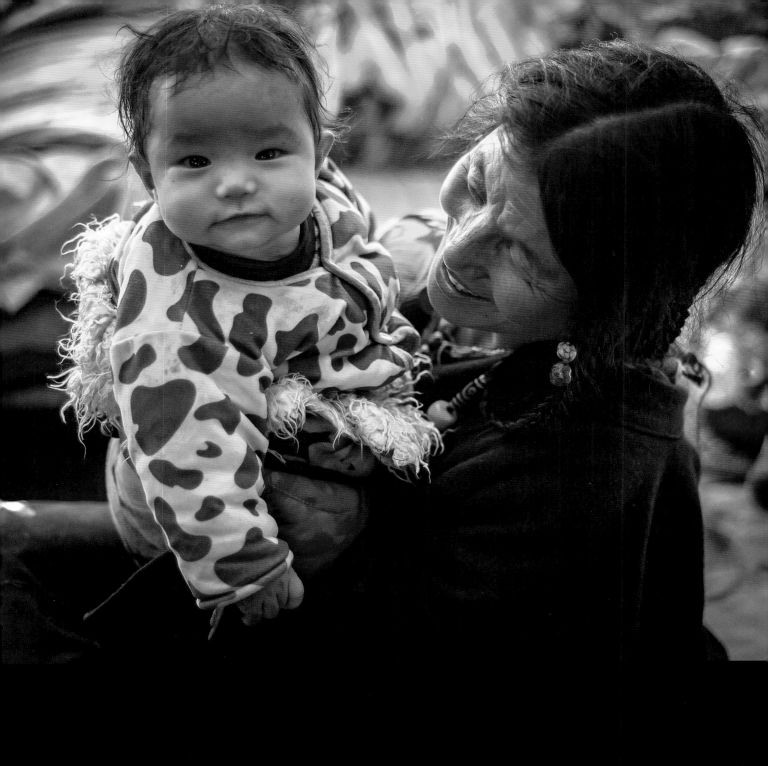

Palmo with her neighbour's baby, Ramashong Valley, Kham, 2017

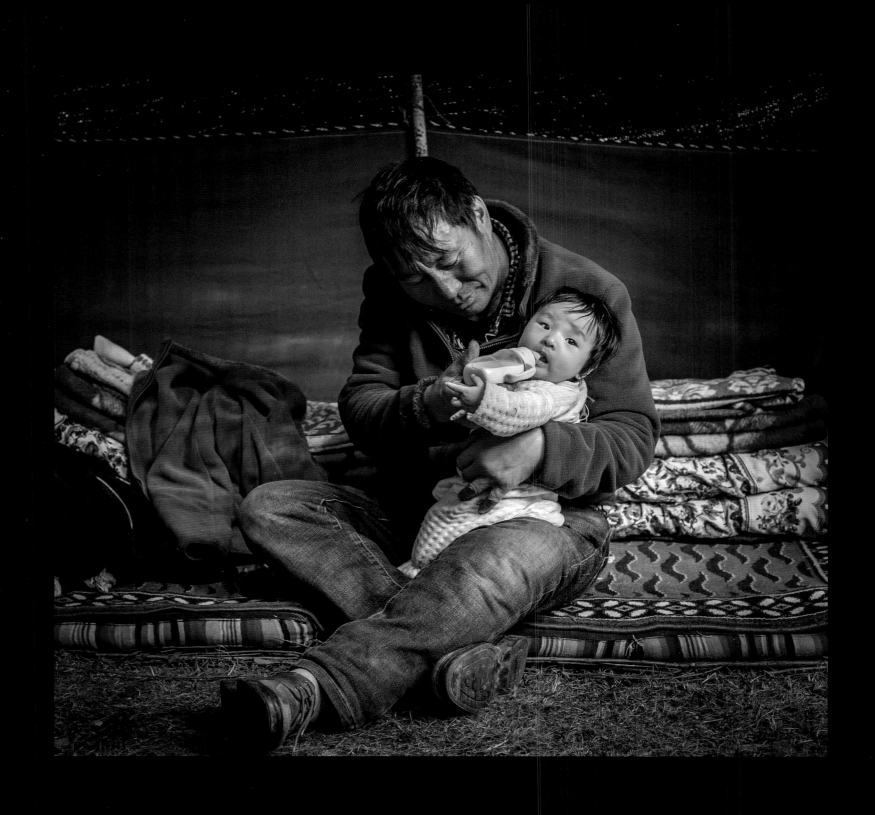

Palmo's husband, Yeshe Tsering, cares for his first grandchild, little Lodre. The women of the family are away in the nearby mountains collecting medicinal herbs. Ramashong Valley, Kham, 2019.

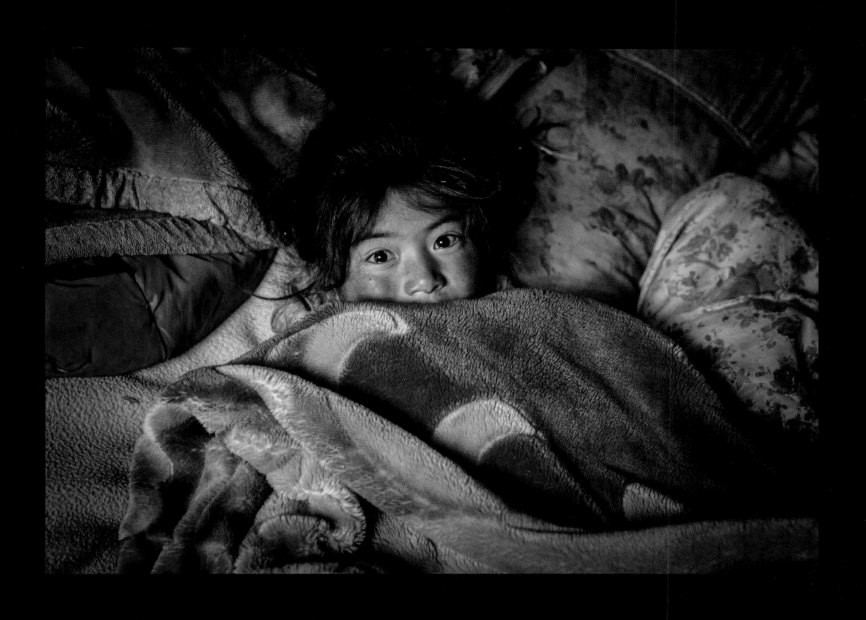

Waking up to find a yellow-haired foreigner in your tent. Nomad life, Ramashong Valley, Kham, 2015.

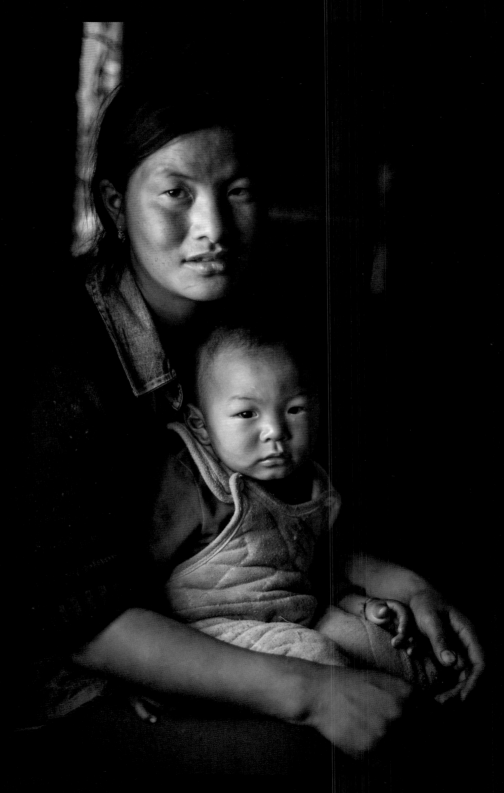

Mehla's cousin-sister with her baby son at the family nomad camp. Kyungchu County, Amdo, 2015.

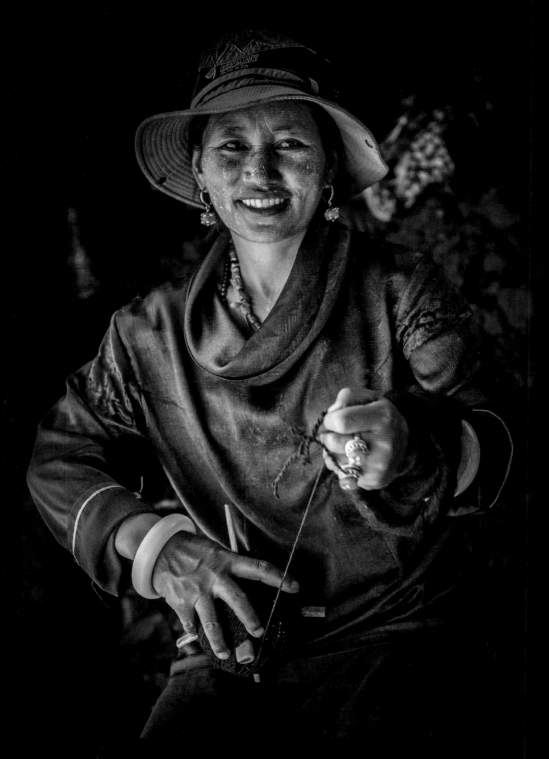

Nomad lady spinning yak wool – the yarn will be used for weaving tent panels or making ropes or slingshots. She has dri yoghurt on her face as a sunscreen. Sershul/Dzachuka nomadic area, Kham, 2015.

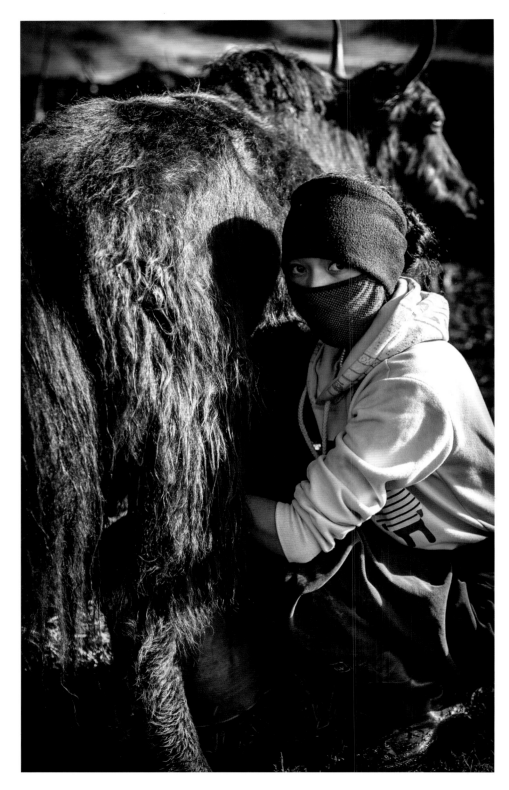

Early morning milking at a nomad camp in Kyungchu County, Amdo, 2015.

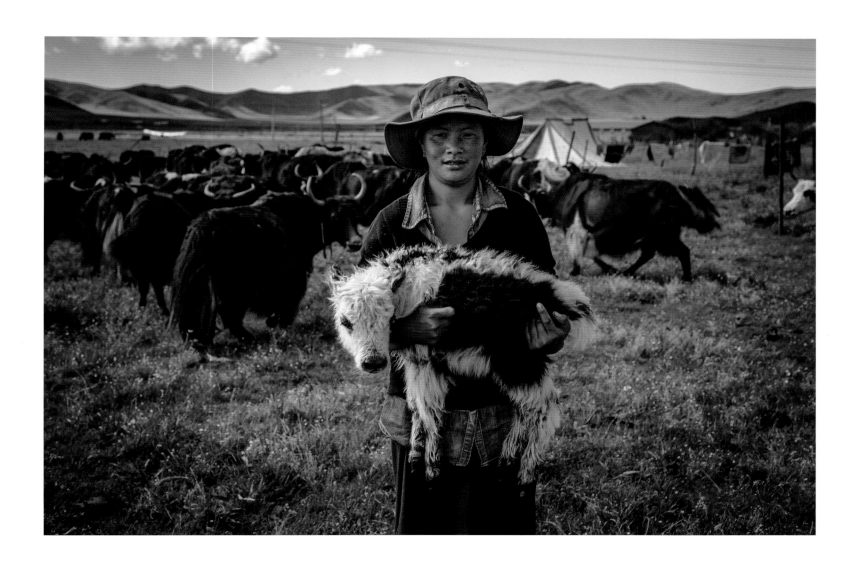

Mehla's cousin-sister, seen here holding a baby yak, corrals all the young at night to protect them from wolves.
Kyungchu County, Amdo, 2015.

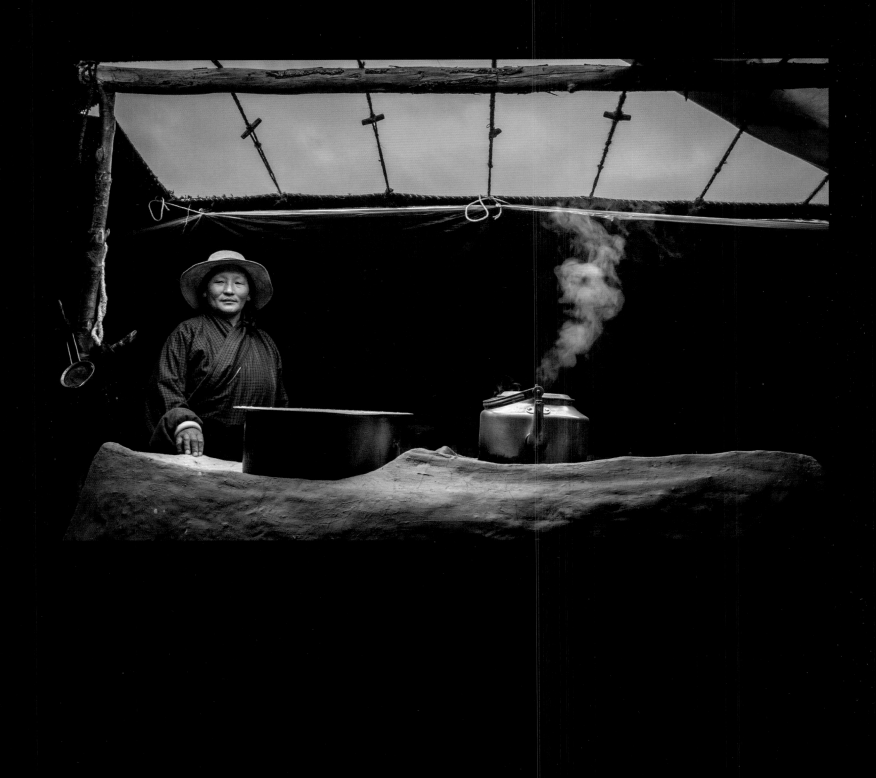

Sengko's mum in the family black tent. Sengko's friend Gyaltso created the magnificent clay stove, or *geipu*, in these spring quarters. The stove is made from large stones and mud and will be left behind when the family move. It then biodegrades back into the ground. Above is the *kung* (meaning sky), the opening through which the smoke from the stove can escape. Sershul/Dzachuka area, Kham, 2018.

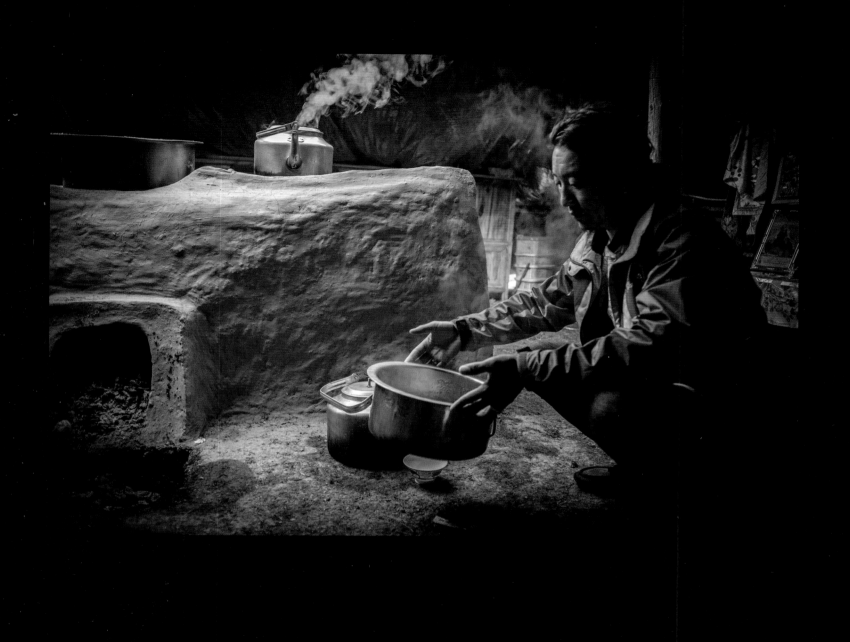

Sengko prepares tea for visitors. He wove the panels for the family black tent himself and was proud that the interior was beautifully and traditionally furnished, but this is now the only black yak-hair tent left in his *rukor* – the rest are white canvas. Sershul/Dzachuka nomadic area, Kham, 2018.

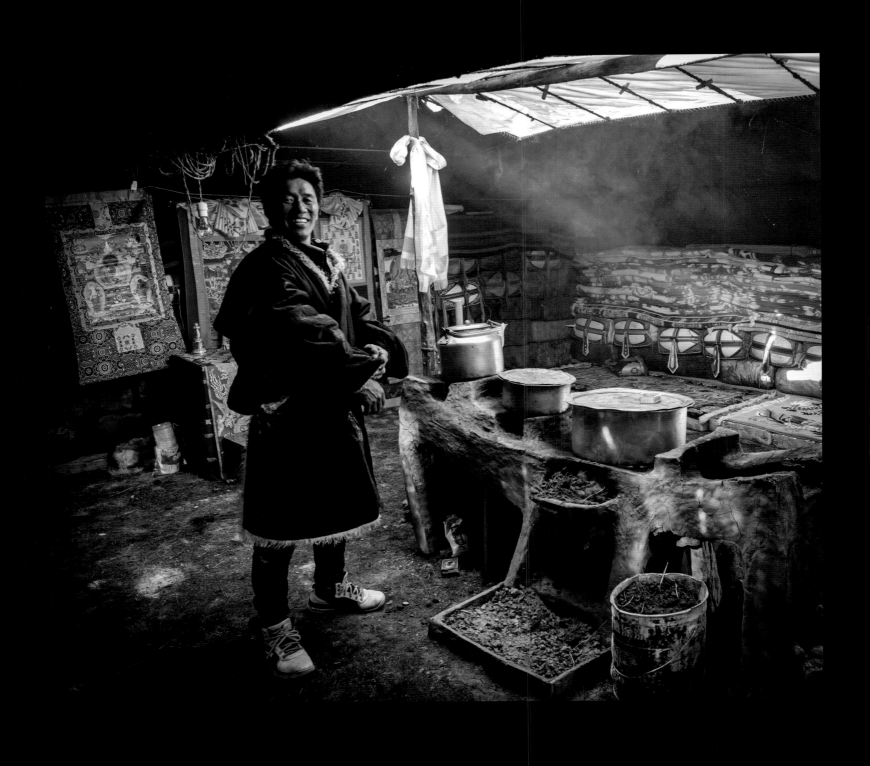

Yulha in the traditionally set-up tent of his newly married friends, Wangchen Gonpo and his wife. Many nomads prefer metal stoves these days, as they are light and easy to move around, but Yulha told me that they do not hold the heat like a clay stove, cooling down very quickly. Clay stoves can hold heat for up to two days, are warmer and use less fuel (dry or frozen yak dung). Dzagaly, Sershul/Dzachuka area, Kham, 2018.

Tibetan nomads would offer the first spoon of freshly boiled milk to the stove itself, since they believe that there is a deity of the stove and they identify it with the Konckok – the Three Jewels of Buddhism.

In the past you wouldn't see many cups on the stove. The nomads would show the stove a lot of respect, as they believed a lha inhabited it. The stove was seen like the mother of the household, as all the food comes from it, so there's a lot of devotion to the stove.

Gebchak Wangdrak Rinpoche

Like a mother who protects her child, her only child, with her own life, one should cultivate a heart of unlimited love and compassion towards all living beings.

The Buddha

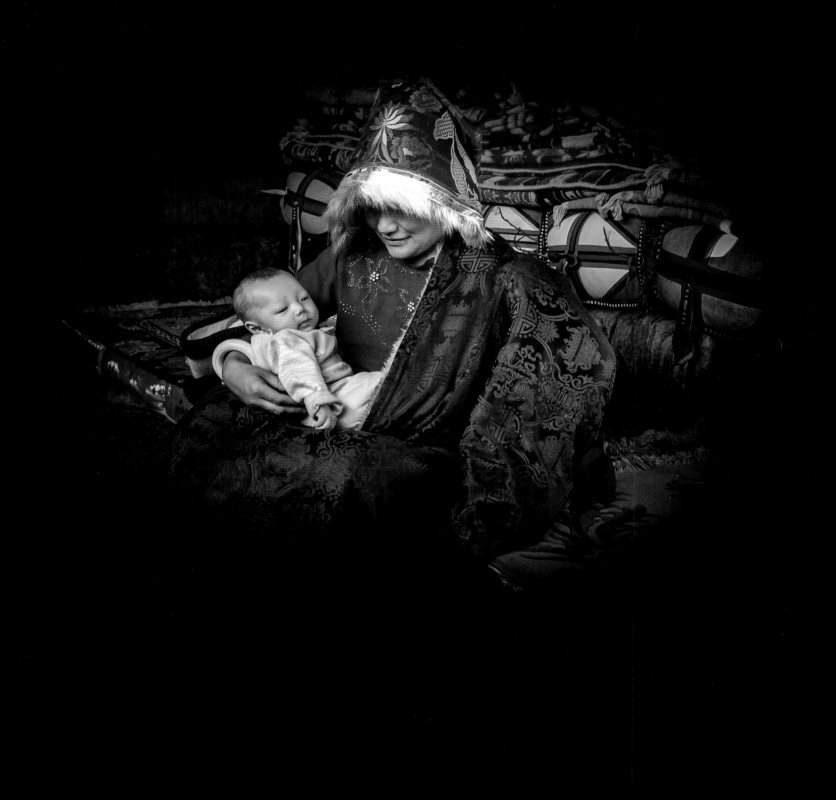

Wangchen Gonpo's wife relaxes with their baby in the family black tent. Dzagaly, Sershul/Dzachuka area, Kham, 2018.

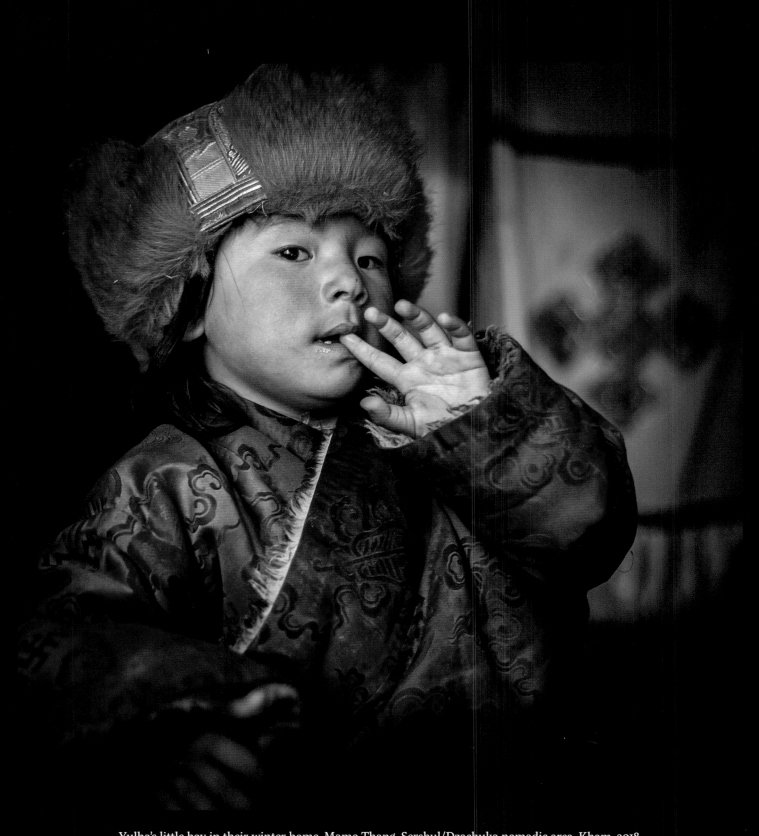

Yulha's little boy in their winter home. Mamo Thang, Sershul/Dzachuka nomadic area, Kham, 2018.

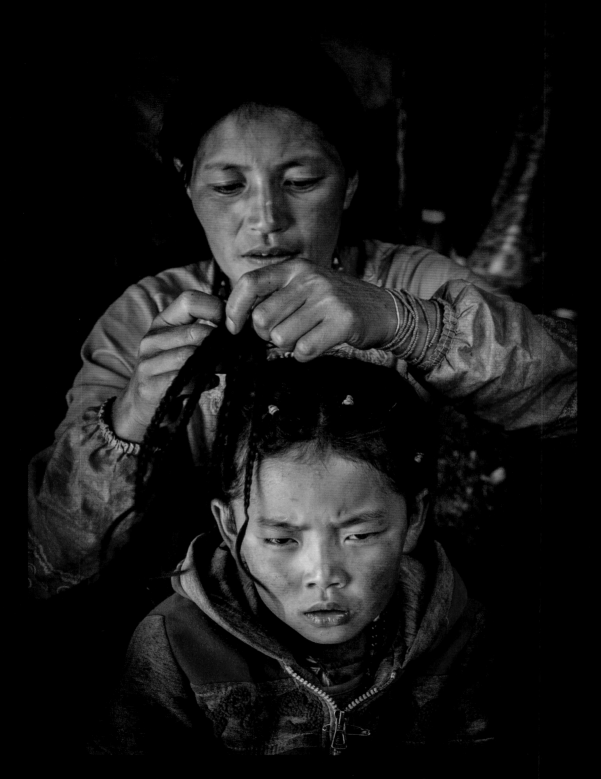

Nomad mum doing her daughter's hair. Sershul/Dzachuka nomadic area, Kham, 2015.

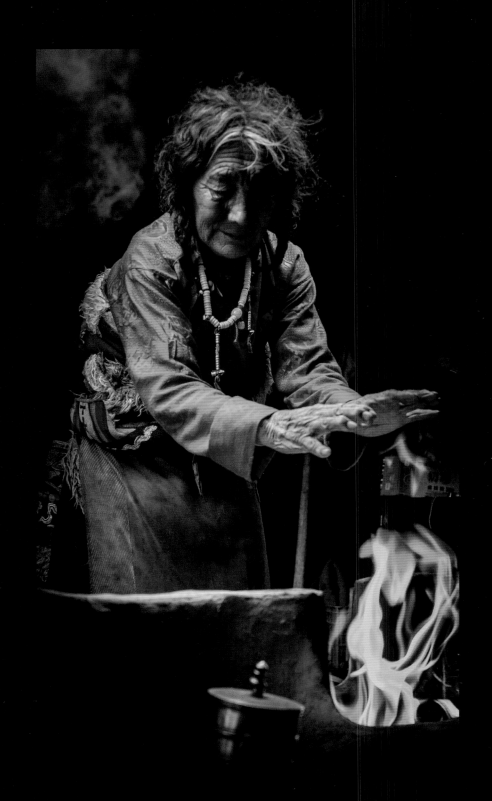

Trachang Palsang's mum in the family black tent. Despite their simple nomad background, her son Palsang was able to go to university in Lhasa. Ma Chu (Yellow River) area, Amdo, 2017.

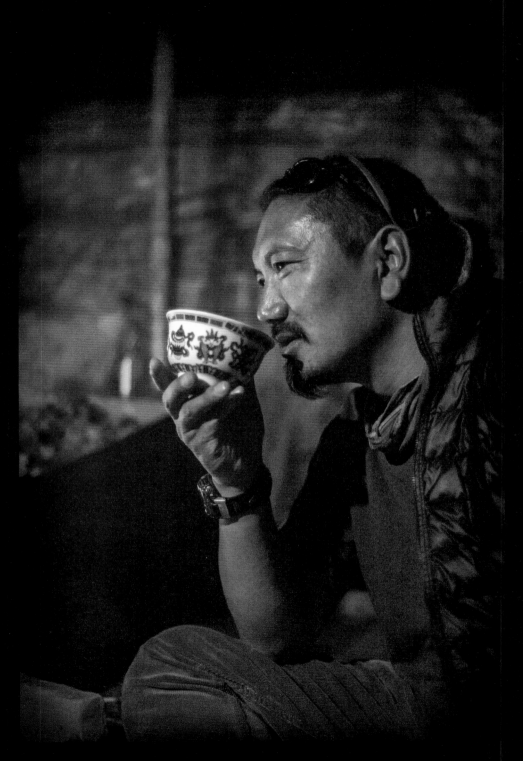

Palsang drinking tea in his mum's black tent. Palsang has become noted for developing a simple, cheap and highly effective way of re-greening desertified grasslands in his area. Many of the ideas are the result of listening to nomad women like his mum. Ma Chu area, Amdo, 2017.

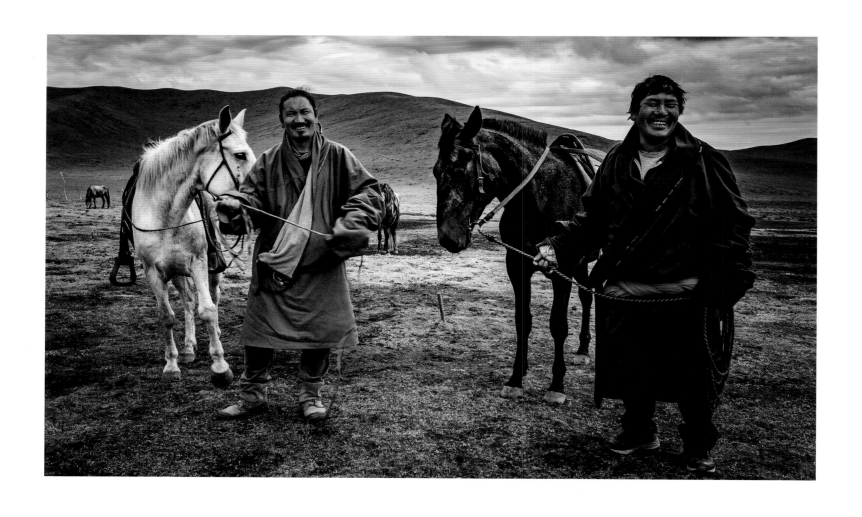

Palsang and his brother with their beloved horses at the family nomad camp. Ma Chu area, Amdo, 2017.

'This is how I feel about a life of herding. Truthfully that feeling comprises grassland, yaks, sheep, horses and young men and women. The feeling is as if I have the whole world. I have been many places but they can't produce this feeling.'
Trachang Palsang in interview with Tracy Burnett

This centre of heaven,

This core of earth,

This heart of the world,

Fenced round with snow,

The headland of all rivers,

Where the mountains are high and

The Land is pure.

A country so good

Where men are born as sages and heroes

And act according to good laws.

A land of horses ever more speedy.

Anonymous Tibetan poet, 8th to 9th century

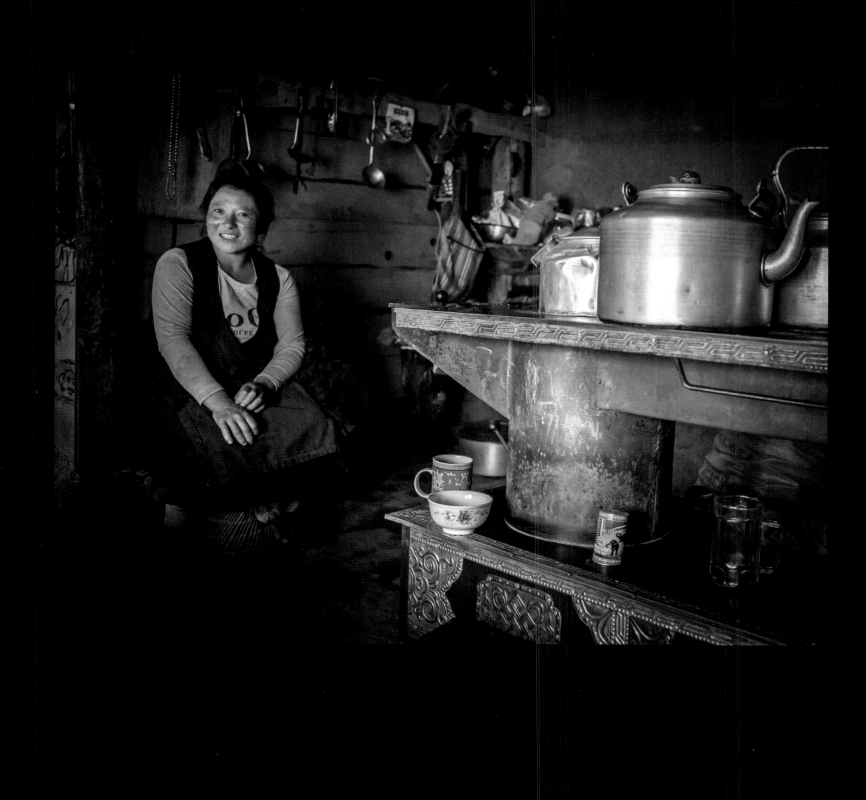

Above and page 125: Aga in the kitchen of her nomad family's winter home. When pictured, the family were about to move to a tent in their spring pastures the following day. Mudi Mountain, near Rongpatsa, Kham, 2018.

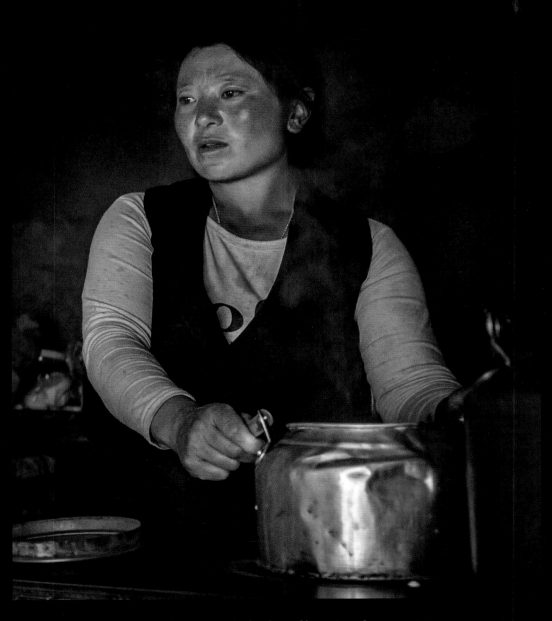

Aga making tea in the kitchen of her winter home, 2018.

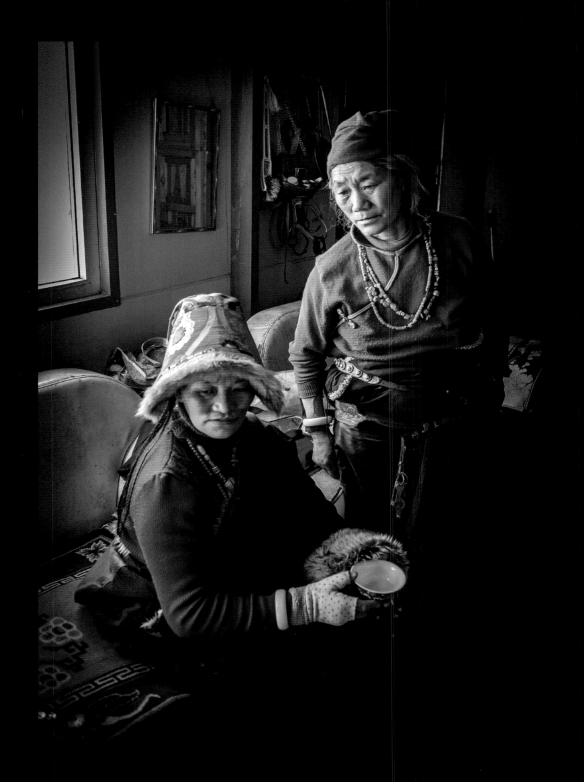

Pentsok with her old friend Yeshe Lhamo. Pentsok and husband Gyaltso have given up their herd of dri, whereas Yeshe Lhamo is still living the nomad life. Yetso Nyimpa winter settlement, Mamo Thang, Sershul/Dzachuka nomadic area, Kham, 2018.

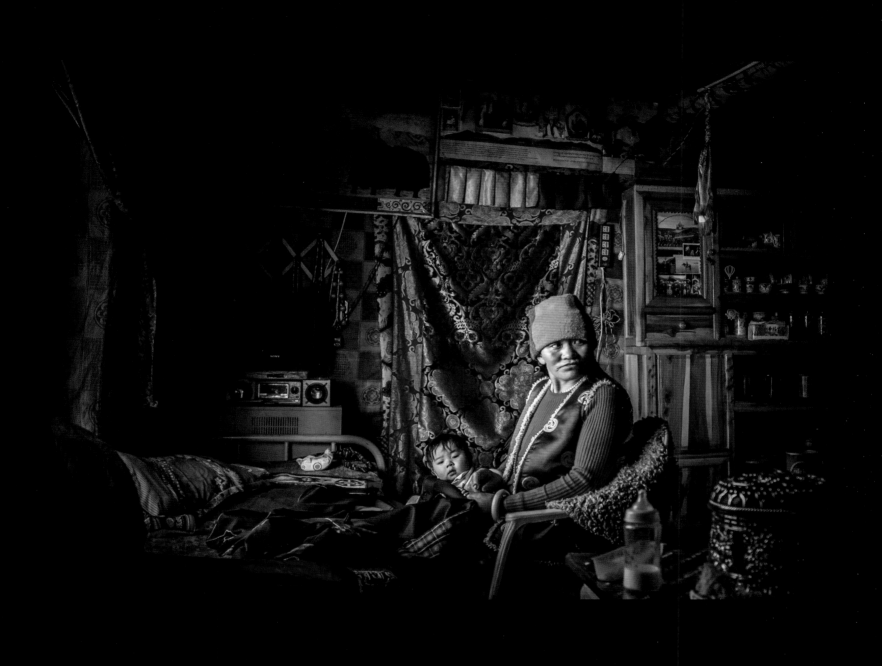

Pentsok stitching a new *chuba* for her husband, Gyaltso. The family sold their herd of dri, settled permanently in their winter quarters and took 'resting grasslands' income from the local government.
Mamo Thang, Sershul/Dzachuka nomadic area, Kham, 2018.

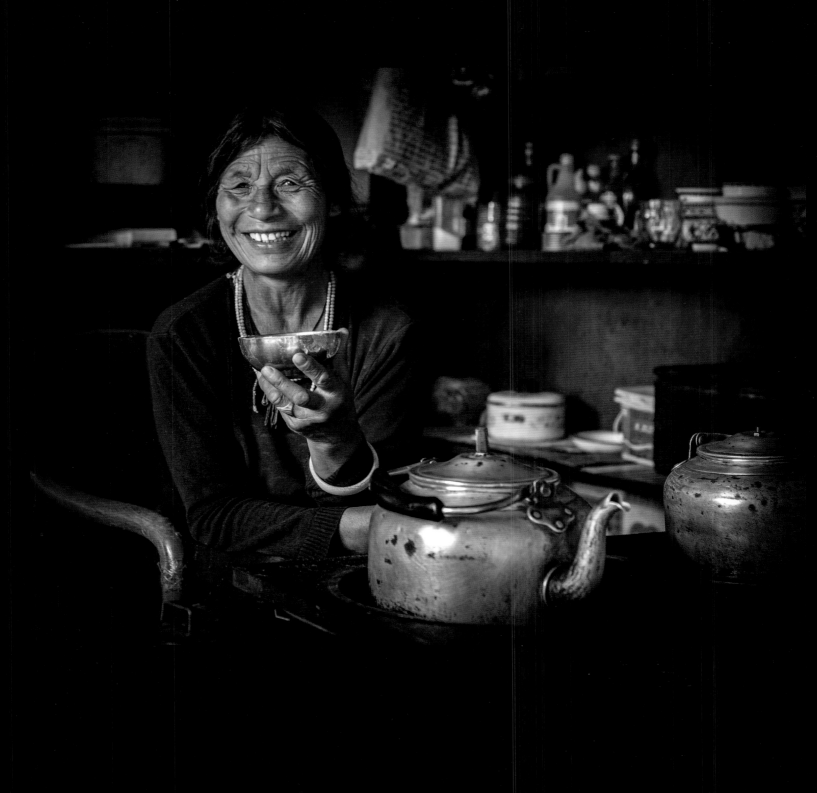

Warm and welcoming, Mehla's lovely mum lit up my stay in her home (a nomad resettlement village) and sent me back to Chengdu with a huge vat of yoghurt from her son's herd of yak and dri. Her two sons still live the nomad life, her daughter Mehla lives with her husband in Chengdu and mum and dad care for several grandchildren so they can go to school locally. Kyungchu County, Amdo, 2015.

If we divided this earth into pieces the size of juniper berries,

the number of these would not be as great as the number of times

that each sentient being has been our mother.

Nagarjuna

A friend gives what is hard to give, and does what's hard to do.

They put up with your harsh words, and with things hard to endure.

The Buddha

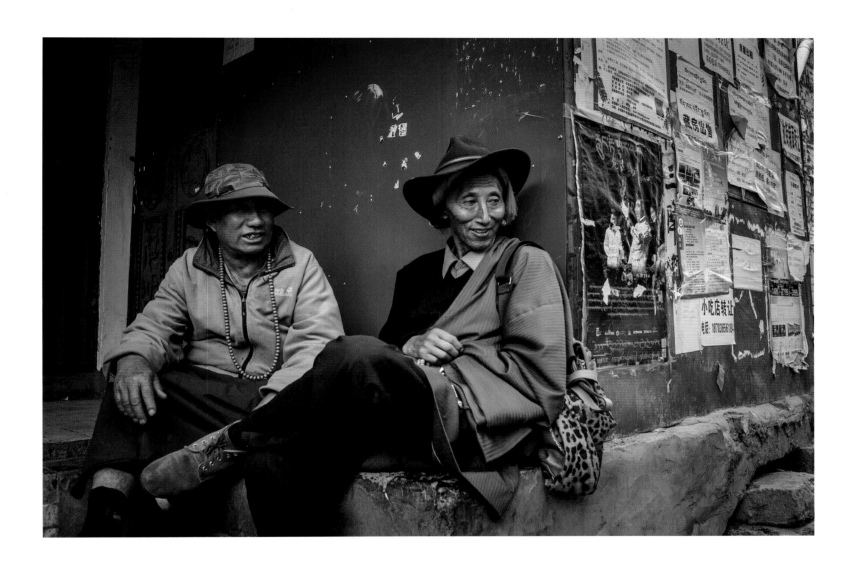

A monk and his friend. Kandze, Kham, 2016.

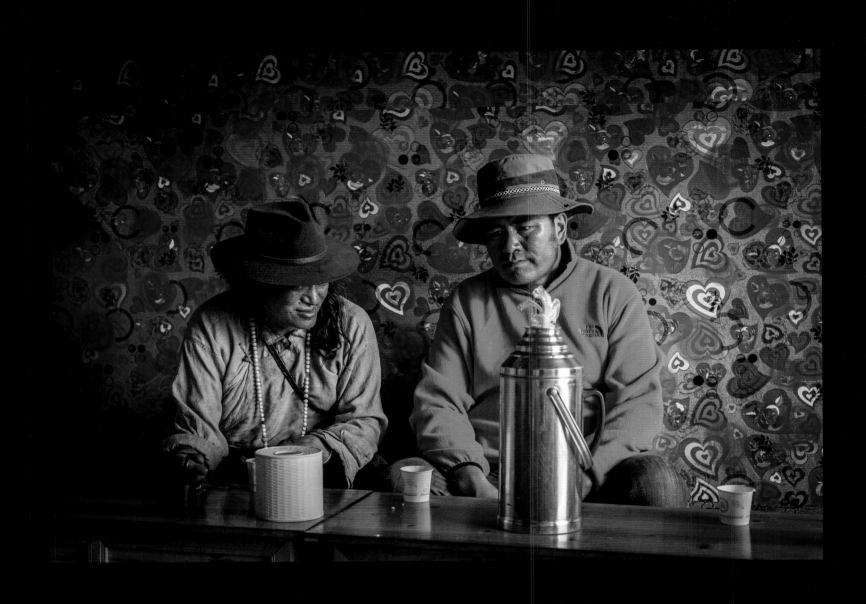

Nomads come to town, drinking tea in a cafe. Manigengo, Kham, 2018.

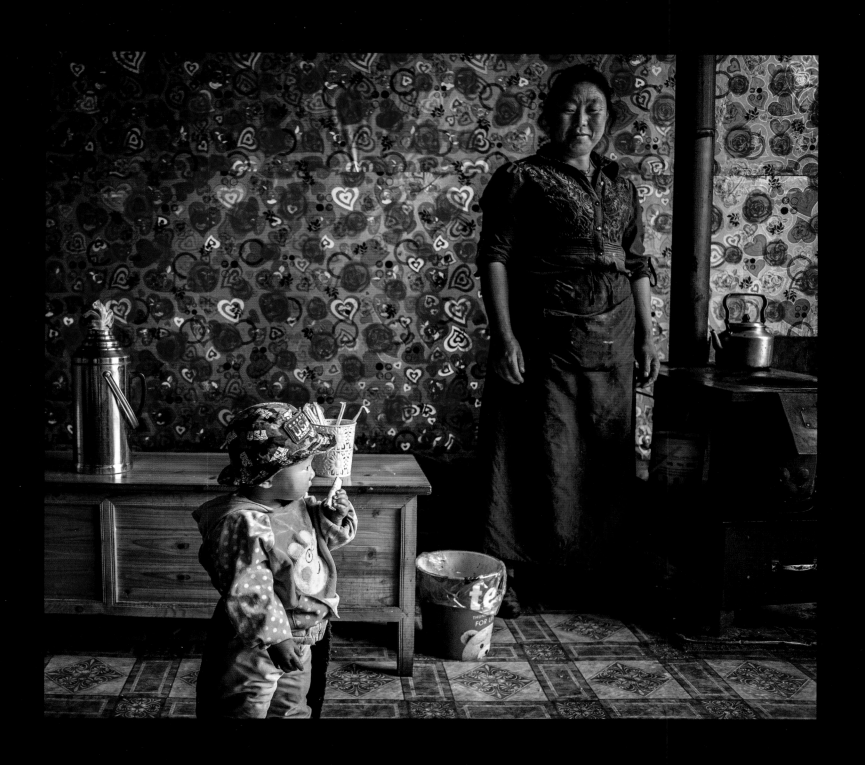

Mother and child in a cafe. Manigengo, Kham, 2018.

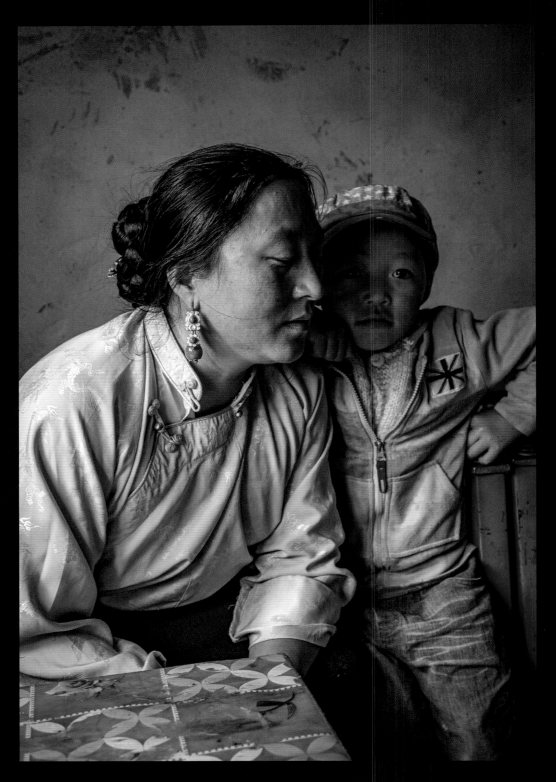

Awang, together with her husband Choeden, has the role of parent to 21 children orphaned in the 2010 Yushu earthquake.
Jyekundo (Chinese: Yushu), Nangchen, Kham, 2015.

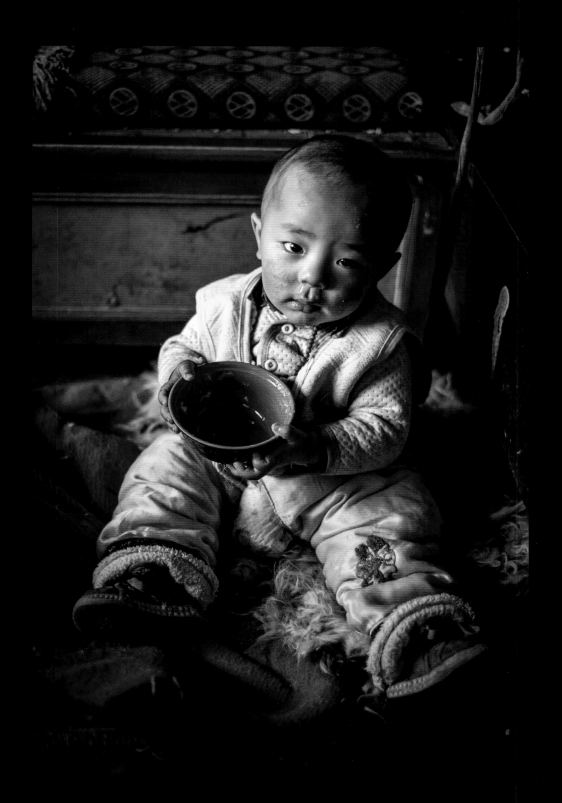

Jamie Monroe (name given by a Scottish friend who spent time with the child), adopted into a family of the Dong Tsang clan. Sharda, Nangchen, Kham, 2014.

When one speaks of the virtues of women, they surpass those of all living beings.

Wherever one finds tenderness or protectiveness, it is in the minds of women.

They provide sustenance to friends and strangers alike.

A woman who is like that is as glorious as Vajrayogini herself.

From the Candamaharosana Tantra

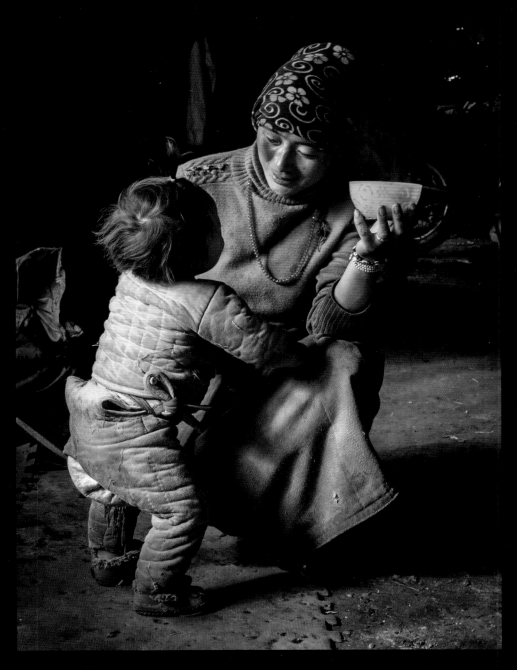

Sonam Wangbo's wife Pema with her youngest son in the family spring quarters. Dahu Valley, Kham, 2016.

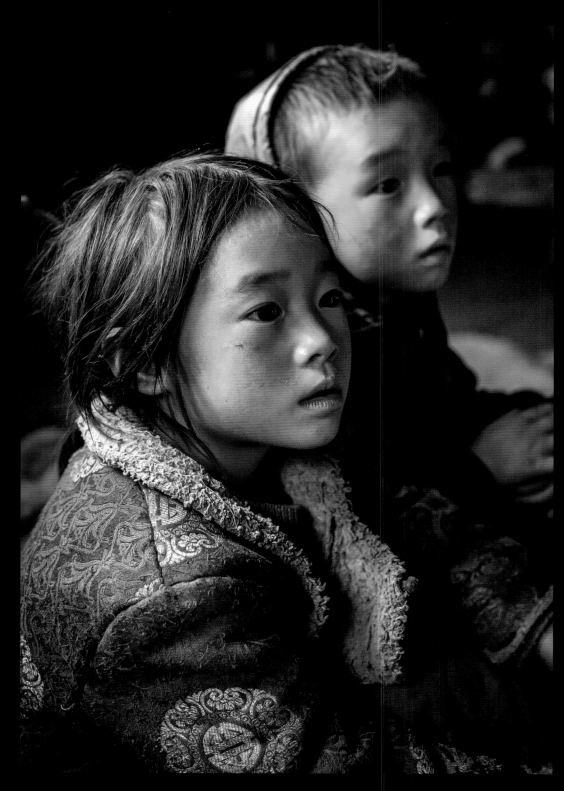

Listening to their dad, Sonam Wangbo, telling stories. The sacred Dahu Valley, Kham, 2016.

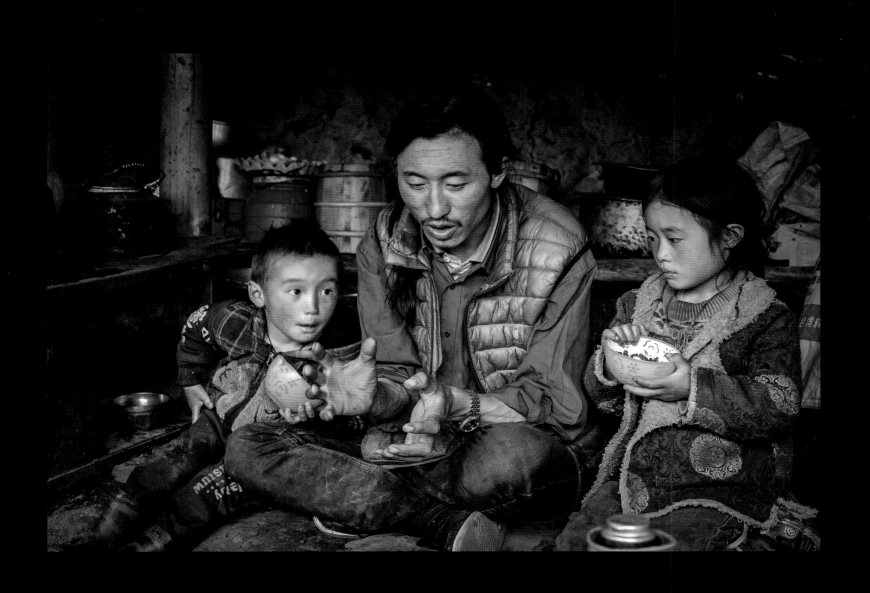

Nomad friend Sonam Wangbo telling us how he once saw a dragon in his high summer pastures, using his hands to describe the power of the dragon descending. He related the encounter as if it was the most normal thing in the world and then moved on to the topic of a new road coming through the area. Spring quarters, Dahu Valley, Kham, 2016.

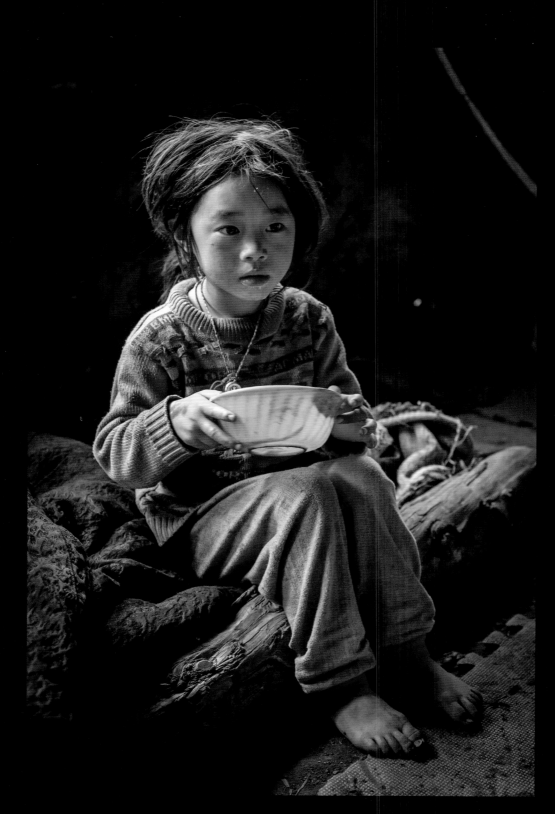

Sonam Wangbo's daughter has finished her *tsampa*. Spring quarters, Dahu Valley, Kham, 2016.

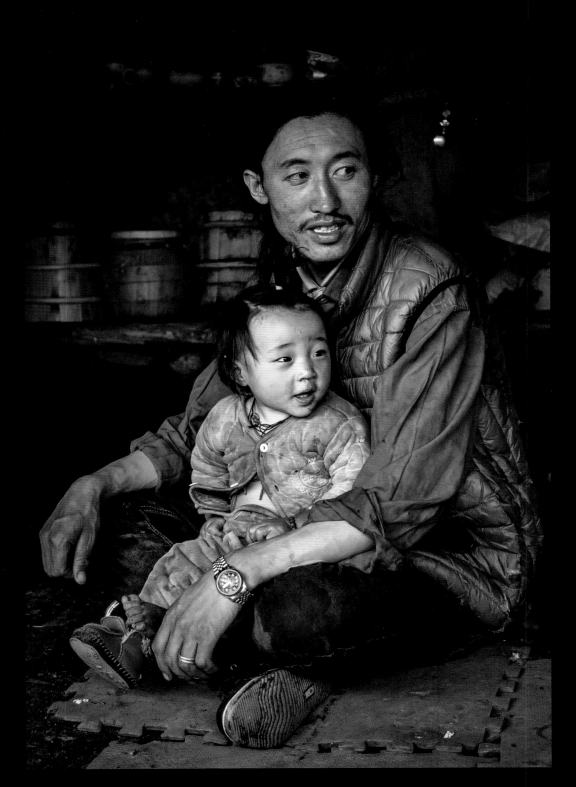

Sonam Wangbo with his youngest son. Spring quarters, Dahu Valley, Kham, 2016.

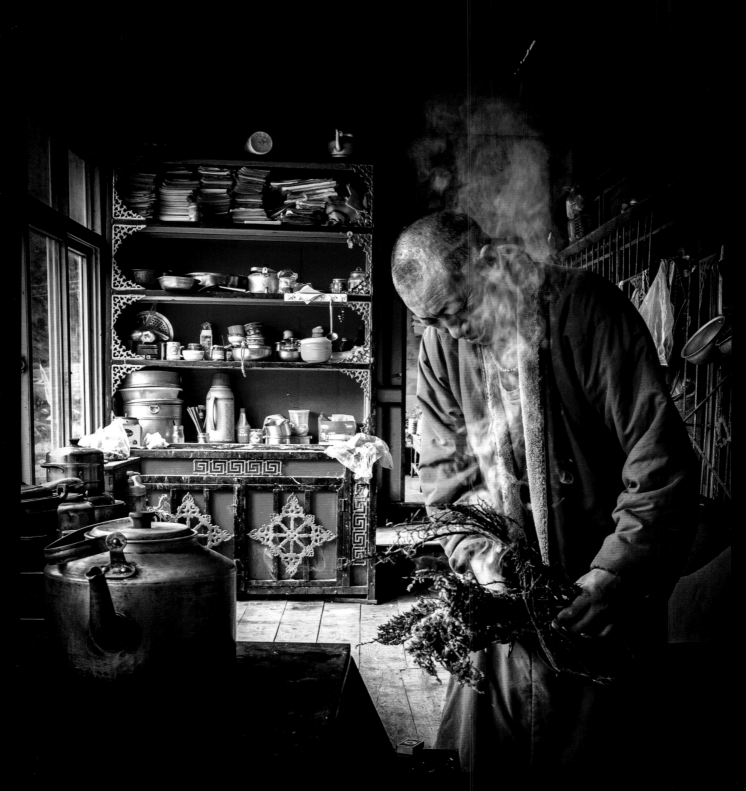

In the family's winter quarters, Sonam Wangbo's uncle, a monk, prepares to light the stove to make us a cup of tea, followed later by *thukpa*, Tibetan noodle soup. Dahu Valley, Kham, 2019.

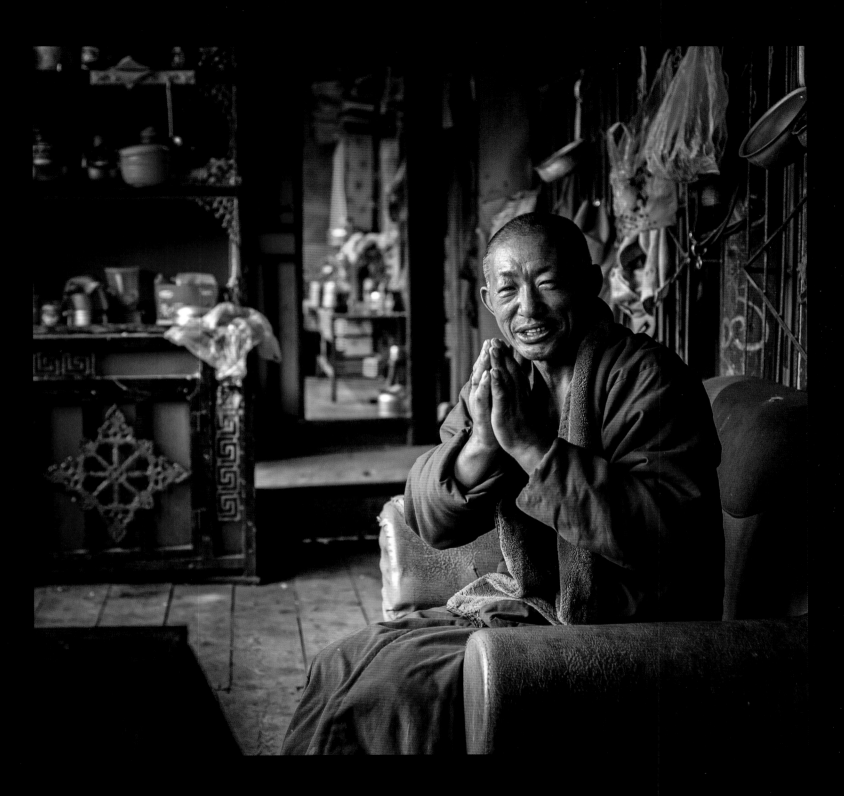

Uncle lives year round in the family winter home, doing his spiritual practice and keeping an eye on the place.
Dahu Valley, Kham, 2019.

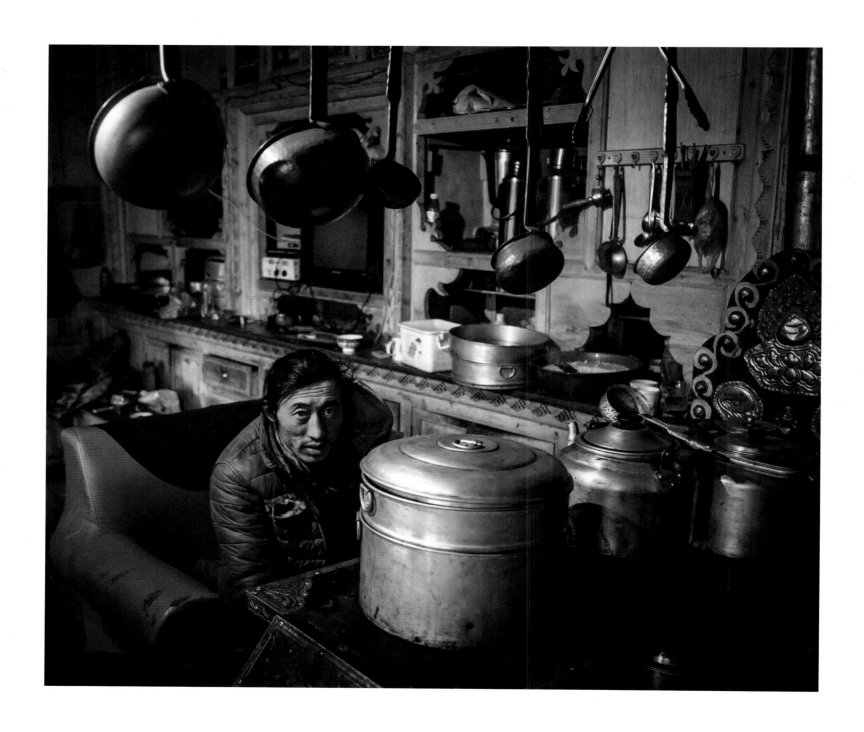

After bringing the herd home in the evening, Sonam Wangbo relaxes by the stove in his winter home. Dahu Valley, Kham, 2018.

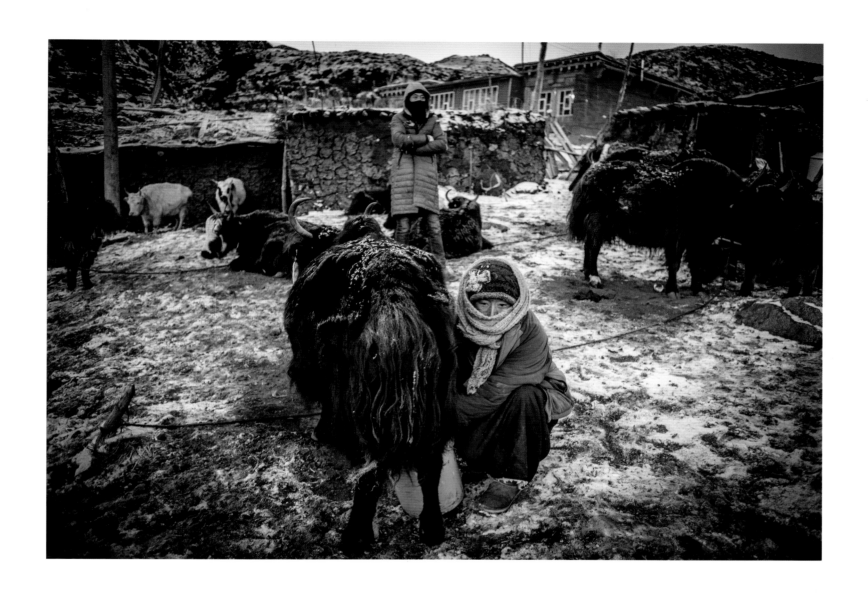

Pema milking on a cold December morning in front of the family's winter home. At this time of year the dri produce less milk and so Pema will only be milking once a day. In winter the family have less work to do and can relax more.
Dahu Valley, Kham, 2018.

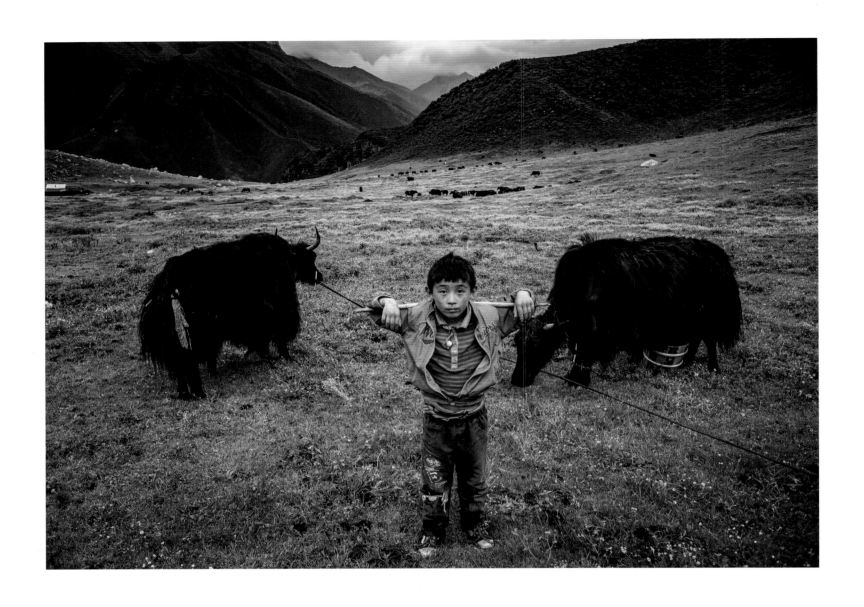

One of the children joins his mum Pema in the pastures as she milks. Mum is hidden behind the dri on the right, with just her wooden milking pail visible. Dahu Valley, Kham, 2016.

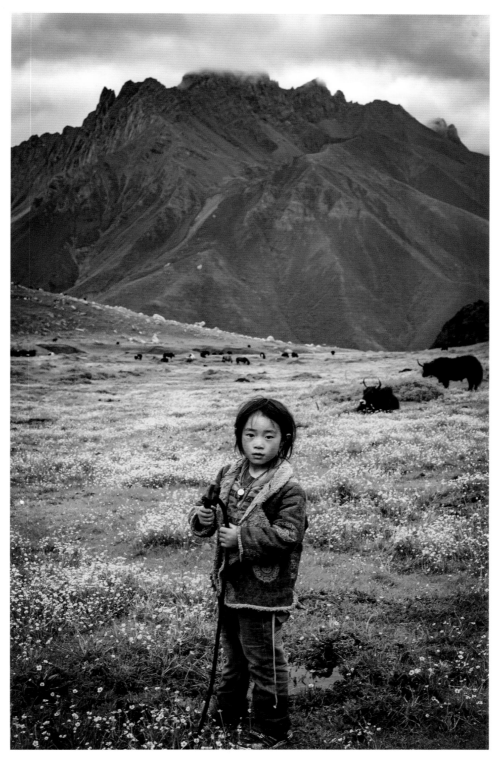

Sonam Wangbo's youngest daughter in the spring pastures. She is holding a *charu*, a toggle on a rope that helps link dri together for milking. It is also seen as a symbol of connection between people. Dahu Valley, Kham, 2016.

I am never far from those with faith,

Or even those without it, though they

Do not see me. My children will always,

Always, be protected by my compassion.

Guru Rinpoche

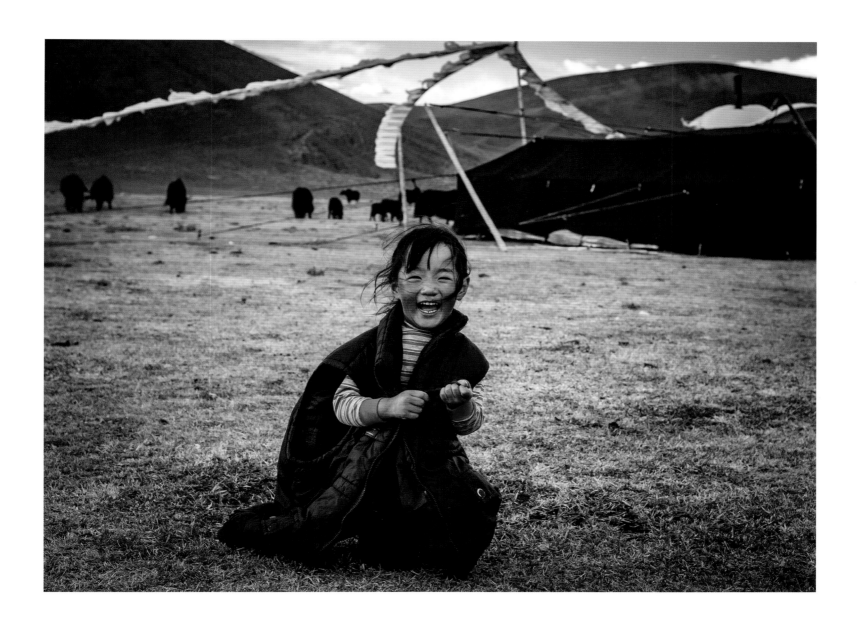

Happiness at the nomad camp, Sershul/Dzachuka nomadic area, Kham, 2015.

DIANE BARKER

Diane Barker is a photographer and artist based in a small Worcestershire village. She was born in a pub and still lives in the home of her birth. She studied Art History at the University of East Anglia and went on to do an MA involving a landscape photo project at the University of Central England. Diane's nomadic roots trace back to the 70s as a hippie living in a camper van in America, and at age 25 she met her first Tibetans, when the 16th Karmapa and his entourage visited Wales.

In her 30s she became a painter, exhibiting widely in London and around the UK, and in her 40s photography took over when she began travelling to India. A Buddhist boyfriend, teaching English to Tibetan monks in Sikkim, took her into the heart of the Tibetan community and she began documenting their lives along with those of Indian village people in the Himalayan foothills.

She first encountered Tibetan nomads, or Drokpa, in 1999 in the Changthang of Ladakh and fell in love with the rawness, beauty and simplicity of their traditional earth-based culture. Ever since then the Tibetan nomads became her photographic obsession, the subject of her heart, and she has travelled extensively in eastern Tibet (now part of Sichuan Province, Gansu, Qinghai, Yunnan and TAR, China) documenting nomad life.

She has created exhibitions which have toured around the UK, as well as to Mumbai, India. Many of her photos have been exhibited in group shows in the UK, India and New York and her work has also appeared in many books, publications and online platforms. Her solo published works are *Tibetan Prayer Flags* (Connections Book Publishing) and *The Eternal Land* (East West Publications).

www.dianebarker.net @tibetannomadproject @dianebarker108

In Art as well as life, anything is possible provided there is Love.

Marc Chagall

One looks, looks long, and the world comes in.

Joseph Campbell

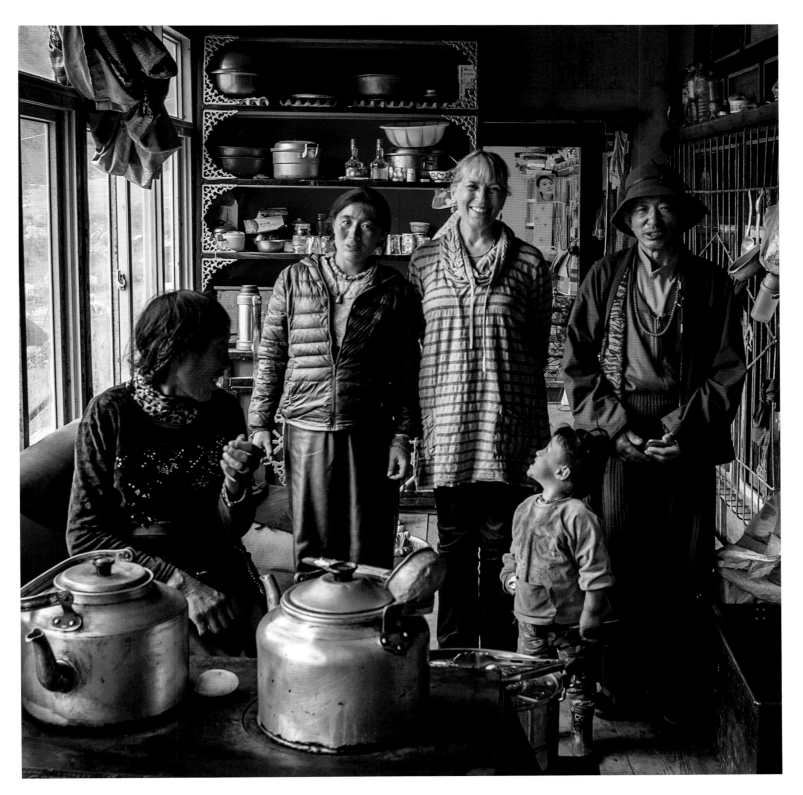

Diane with Sonam Wangbo's family. Dahu Valley, Kham, 2017.

PLATE INDEX

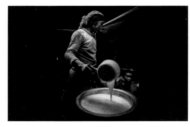

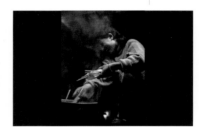

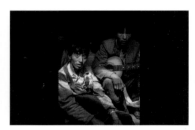

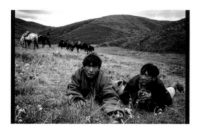

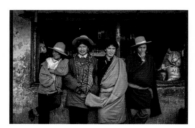

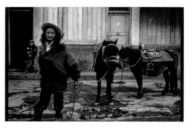

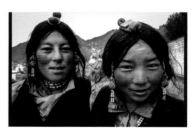

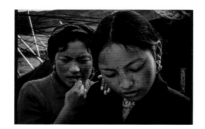

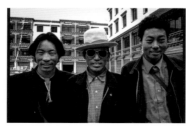

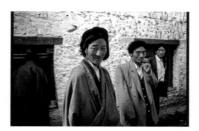

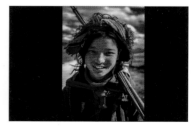

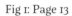

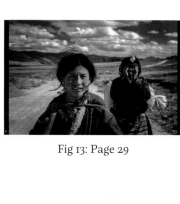

Fig 13: Page 29

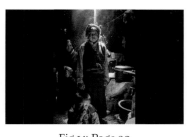

Fig 14: Page 30

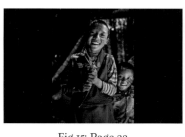

Fig 15: Page 32

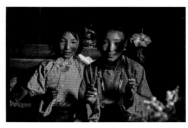

Fig 16: Page 33

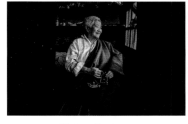

Fig 17: Page 34

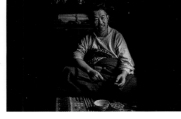

Fig 18: Page 35

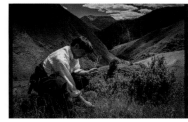

Fig 19: Page 36

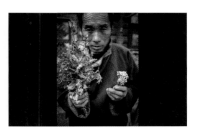

Fig 20: Page 37

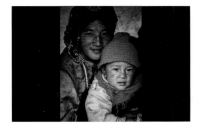

Fig 21: Page 38

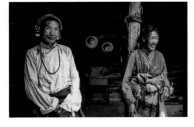

Fig 22: Page 39

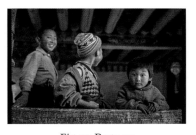

Fig 23: Page 40

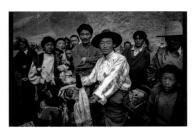

Fig 24: Page 41

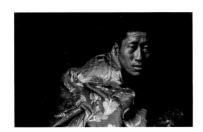

Fig 25: Page 42

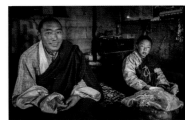

Fig 26: Page 43

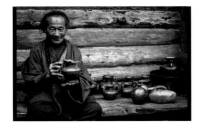

Fig 27: Page 44

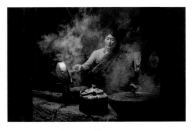

Fig 28: Page 49

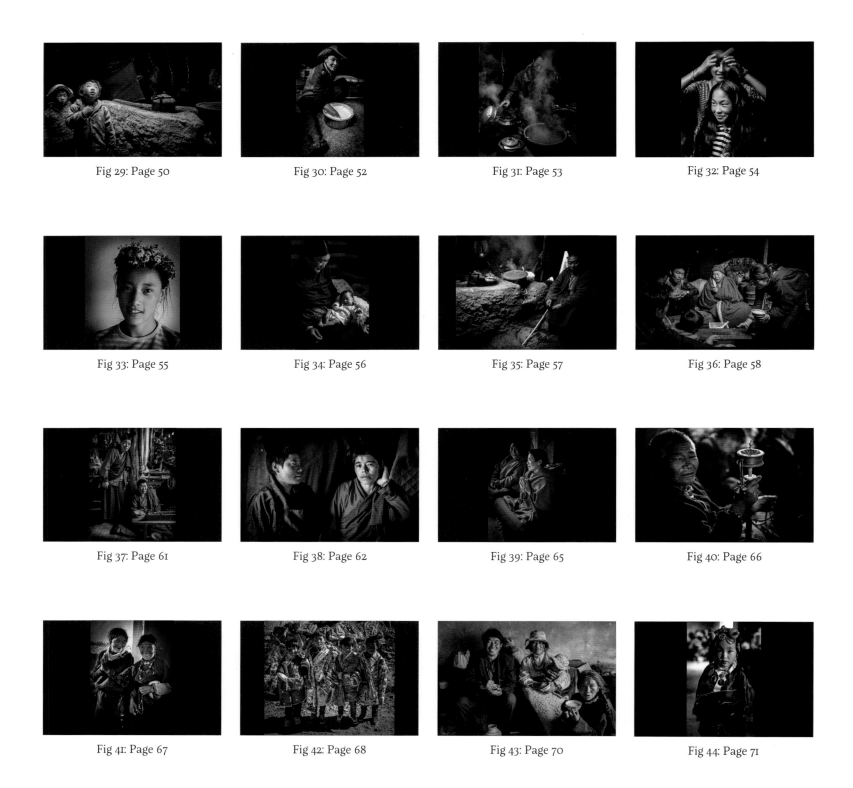

Fig 29: Page 50

Fig 30: Page 52

Fig 31: Page 53

Fig 32: Page 54

Fig 33: Page 55

Fig 34: Page 56

Fig 35: Page 57

Fig 36: Page 58

Fig 37: Page 61

Fig 38: Page 62

Fig 39: Page 65

Fig 40: Page 66

Fig 41: Page 67

Fig 42: Page 68

Fig 43: Page 70

Fig 44: Page 71

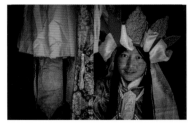

Fig 45: Page 72

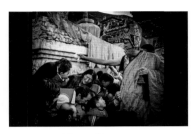

Fig 46: Page 73

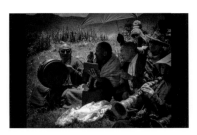

Fig 47: Page 74

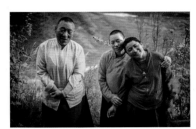

Fig 48: Page 75

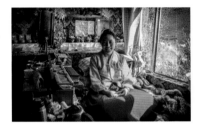

Fig 49: Page 76

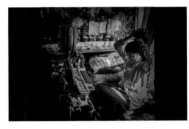

Fig 50: Page 77

Fig 51: Page 79

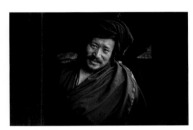

Fig 52: Page 80

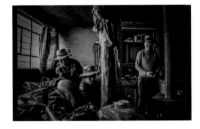

Fig 53: Page 84

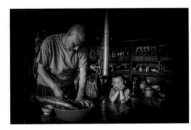

Fig 54: Page 86

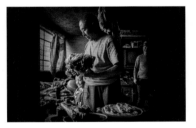

Fig 55: Page 87

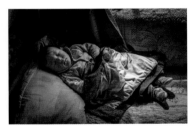

Fig 56: Page 88

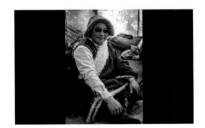

Fig 57: Page 90

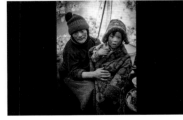

Fig 58: Page 91

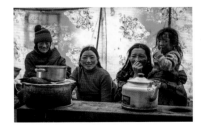

Fig 59: Page 92

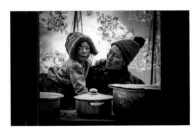

Fig 60: Page 93

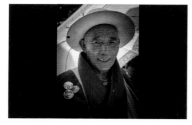

Fig 61: Page 94

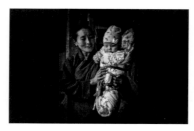

Fig62: Page 96

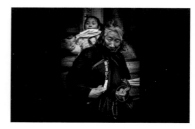

Fig 63: Page 97

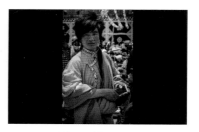

Fig 64: Page 98

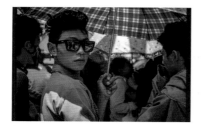

Fig 65: Page 99

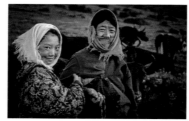

Fig 66: Page 100

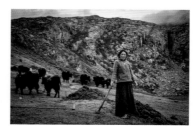

Fig 67: Page 101

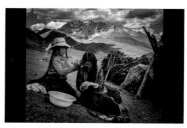

Fig 68: Page 102

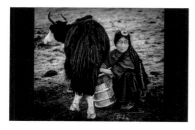

Fig 69: Page 103

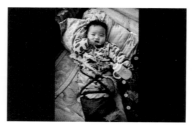

Fig 70: Page 104

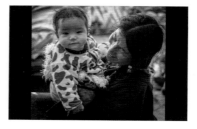

Fig 71 Page 105

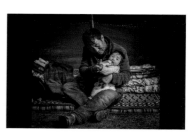

Fig 72: Page 106

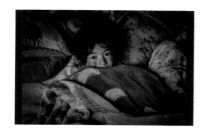

Fig 73: Page 107

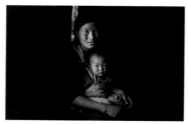

Fig 74: Page 108

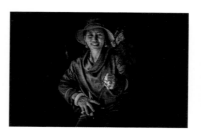

Fig 75: Page 109

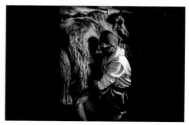

Fig 76: Page 110

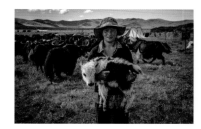

Fig 77: Page 111

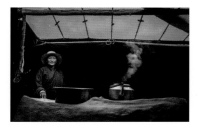

Fig 78: Page 112

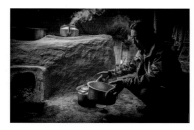

Fig 79: Page 113

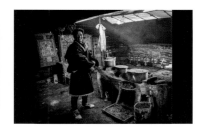

Fig 80: Page 114

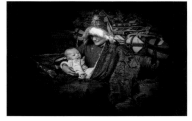

Fig 81: Page 117

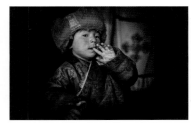

Fig 82: Page 118

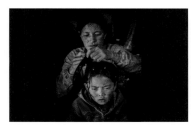

Fig 83: Page 119

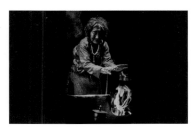

Fig 84: Page 120

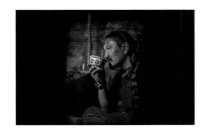

Fig 85: Page 121

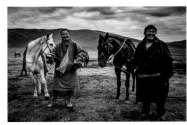

Fig 86: Page 122

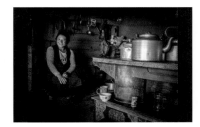

Fig 87 Page 124

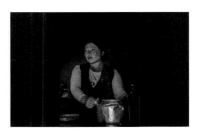

Fig 88: Page 125

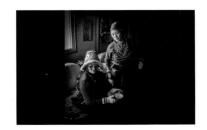

Fig 89: Page 126

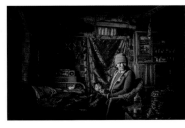

Fig 90: Page 127

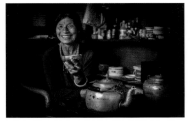

Fig 91: Page 128

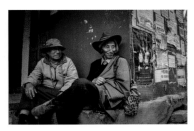

Fig 92: Page 131

Fig 93: Page 132 Fig 94: Page 133 Fig 95: Page 134 Fig 96: Page 135

Fig 97: Page 137 Fig 98: Page 138 Fig 99: Page 139 Fig 100: Page 140

Fig 101: Page 141 Fig 102: Page 142 Fig 103: Page 143 Fig 104: Page 144

Fig 105: Page 145 Fig 106: Page 146 Fig 107: Page 147 Fig 108: Page 149

GLOSSARY

Amdo Amdo consists of former north-eastern Tibet, including the upper reaches of the Machu or Yellow River. Amdo today covers most of Qinghai Province and parts of Gansu and Sichuan Province, China. It is an area of high-altitude grassland.

Arak A distilled spirit of high alcohol content.

Bön The indigenous religion of Tibet before the arrival of Buddhism in the 7th century AD. Followers of Bön are known as Bönpo or Bon-po. Both scholars and the Bönpo themselves distinguish between original Bön and modern Bön. 'Original Bön' refers to the indigenous religion of Tibet, which was animistic (believing that nature is pervaded by good and evil spirits) and shamanistic. Bön as it is practiced now, known as 'New Bön', is essentially a form of Tibetan Buddhism.

Circumambulation See **Kora**.

Cham are Tibetan tantric ritual dances.

Chang Tibetan *chang* is an alcoholic drink, like beer, that is made of barley.

Chuba A *chuba* (also pronounced *chupa*) is the traditional, highly practical robe worn by both men and women all over Tibet.

Drokpa A name used for Tibetan nomads, meaning 'people of the solitudes', or high places.

Dzogchen (or 'Great Perfection', also known as Atiyoga) is the central meditation teaching of the Nyingma school of Tibetan Buddhism, considered to be the highest and most definitive path to enlightenment by this school. Tibetan Buddhist Dzogchen practitioners consider that the state pointed to by these teachings is indescribable with words and can only be discovered through its transmission by an authentic Vajra master.

Kham Kham is a historical region of the old Tibetan Empire, referred to in Tibetan history as 'Chushi Gangdruk', meaning the land of four rivers and six mountains. Today it spans much of Sichuan Province and the Tibet Autonomous Region, with smaller areas also in the provinces of Qinghai, Yunnan and Gansu, China. It is a rugged alpine terrain of mountains and river gorges, with the headwaters of numerous rivers, including the Mekong, Yangtse and the Salween, flowing through Kham.

Khampa People of Kham, noted in legends for the outstanding beauty of the women and the fierce warrior nature of the men, famous for their horsemanship and marksmanship. French explorer Alexandra David-Neel described the men as 'gentleman brigands' and they have a reputation for formerly being either 'great bandits or great meditators'.

Kora Transliteration of the Tibetan term for 'circumambulation' or 'revolution' and involves walking in a circle around a sacred person, object or place – for example temples, monasteries, stupas, mountains, lakes – whilst chanting mantras, saying prayers or making prostrations. It can be seen as purifying, or a way of achieving extra merit or blessings. Buddhists generally circumambulate clockwise whilst Bon pilgrims traditionally orbit in the opposite direction.

Lha Tibetan word used to translate the Sanskrit *deva*, meaning 'deity', 'god' or 'divine'. (Travellers in Tibet traditionally add a stone to the cairns at the tops of hills or passes with a shout of '***Lha**-gyal-Io* – Victory to the Gods'.)

Mani stones/mani wall Mani stones are stones, slates, rocks and pebbles carved with the Tibetan Buddhist mantra **Om Mani Padme Hum**. Mani walls are created from piles of mani stones, often growing in size as pilgrims add more carved rocks as an offering, prayer or to gain merit.

Puja The name given to the wide variety of devotional and offering ceremonies practiced in all Buddhist traditions, *puja* is a Sanskrit word which means 'offering'.

Rinpoche Means 'Precious One' and is used in the context of Tibetan Buddhism as a way of showing respect when addressing those recognized as reincarnated, older, respected, notable, learned and/or accomplished Lamas or teachers of the dharma.

Rukor An encampment of a group of nomad families.

Thukpa Tibetan noodle soup.

Togden yogin Togdens, literally meaning 'having realisation', are yogic practitioners who devote their whole lives to retreat and meditation practice.

Tsampa Staple food in Tibet, made from roasted barley, ground into a flour. It is generally mixed with butter and salty butter tea, and can also be added to soup.

Tulku Used to refer to any reincarnate lama. The tradition of recognising masters who have reincarnated began in Tibet in the early 12th century with the lineage of Karmapas.

Yogin/Yogini One who practises meditation and other techniques in order to unite his or her mind with the actual nature of things. The feminine is yogini.

ACKNOWLEDGEMENTS

This book is dedicated with love to the people of eastern Tibet.

Deep gratitude to Chodrak, who introduced me to his nomad family – the wonderful Chophel and Yeshe – and later invited me to accompany him and his friends on a road trip to Lhasa.

Huge thanks to Oga for taking me to her magical home area, patiently translating everything and instructing me, and for being such a good friend for our month together – much of it on horseback – and to the special people of her area who hosted us and with whom I felt an immediate heart connection.

Also to my dear dharma sister Tenzin Chozom, for introducing me to Wangdrak Rinpoche and the beloved Dong Tsang clan, for her amazing translation skills, her wisdom and her friendship.

Praise to my dharma brother Dawa for being a fantastic and tolerant friend, guide and translator on our many adventures – and to his family for their warmth, friendship and their grace in the face of his many absences whilst he was helping me.

A huge loving thank you to all the families who allowed me into their lives with my camera on subsequent travels and who gave me such generous and genuine hospitality and warmth. I am honoured and proud to be an adopted member of the Dong Tsang clan – in particular Wangdrak Rinpoche, Rabten, Demtso and Yangzom. Thank you also to Yeshe Tsering, his wife Palmo and family and *rukor*, Sonam Wangbo, his wife Pema and family, and to Gyaltso for his hospitality and inspiring introductions. Thank you to Mehla, who introduced me to her warm and welcoming family in Amdo, and to Trachang Palsang and his family – he is amazing!
Thanks too to dear Tracy Burnett, who shared her interviews with Palsang so generously.

I am so indebted to everyone who allowed me to photograph them.

Much loving gratitude to my cousin Simon Perkins and to my friend Stella Astor, for their belief in me and for their backing that made my journeys in eastern Tibet possible. I couldn't have done it without you both. Also grateful thanks to John de la Cour of the Elmley Foundation for his support.

Special loving appreciation to my precious friend Drugu Choegyal Rinpoche, for his inspiration and encouragement, and to my amazing Sufi teacher Llewellyn Vaughan Lee for his unfailing wisdom and guidance.

Gratitude to Peter Gill for his faith in this book, and for the approachable and friendly way he helped me edit hundreds and hundreds of photos. Also thank you to his team at Graffeg – to David for his flexibility, skill and patience with all my many adjustments, and to Daniel for his sensitivity and skill in editing my writing. Thank you also to my agent Katy Loffman at Paper Lion for her invaluable help and advice, and to Hal Robinson, who introduced us.

Deep gratitude to my dear and special friend Jetsunma Tenzin Palmo for her kind, generous and beautifully written foreword.

Big thanks to my old friend and picture researcher extraordinaire Jane Moore, who encouraged my photography from the first time we met in 1992. She generously invited me into her home, shared wonderful connections with me and even found me paid assignments! She really started something.

Finally, a big shout out to all my dear friends at home who have lovingly and patiently helped me edit photos, listened to my ideas and offered theirs: Lesley Rhodes and Ade Shiel, Pippa Galpin, Nick Blood and Heather Galpin, Stella Astor, and Fran Robinson. Love you, guys.

In contrast to the spoken and written word, a picture can be understood anywhere in the world. It can bridge the chasm created by differences of language and alphabet. It is a means for universal communication. It is the language of One World.

Andreas Feininger

Endpapers: Nomad taking his herd to pasture. Near Tso Kar Lake, Ladakh, India, 1999.

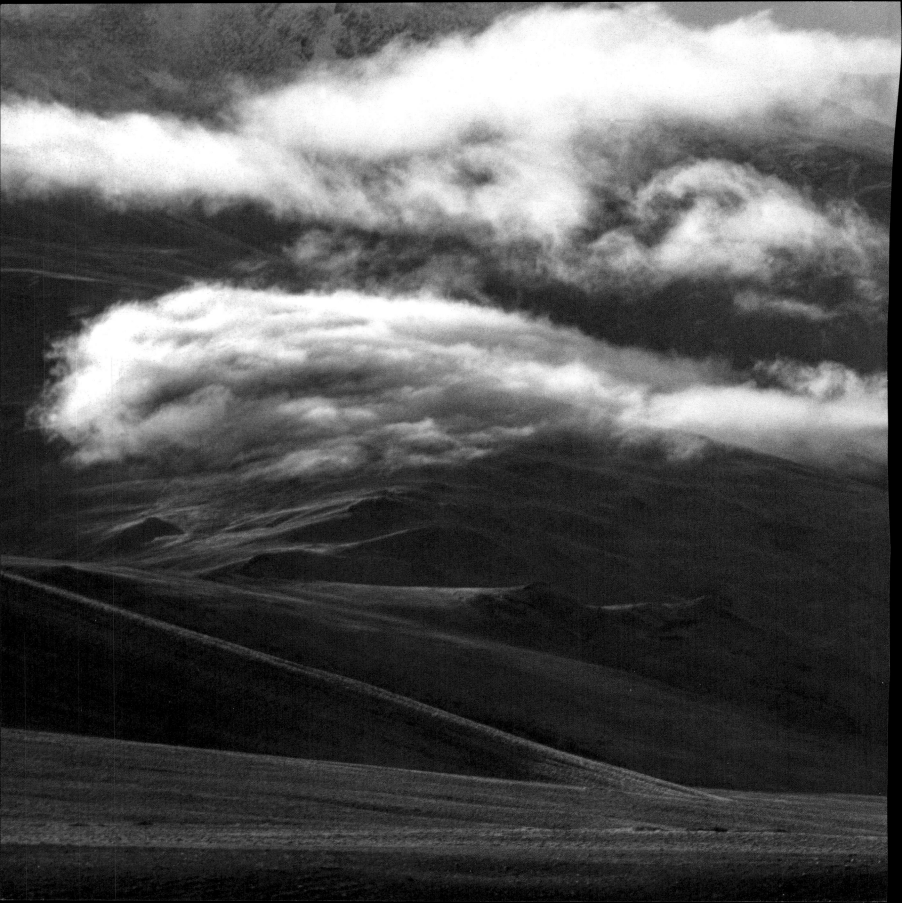